M000102857

A GUIDE TO HISTORIC
Gainesville

A GUIDE TO HISTORIC
Gainesville

STEVE RAJTAR

THE
History
PRESS

Published by The History Press
Charleston, SC 29403
www.historypress.net

Cover image: Photograph of Griffin-Floyd Hall by Edward H. Teague.
Courtesy George A. Smathers Libraries, University of Florida.

All images courtesy of the Florida Photographic Collection unless
otherwise noted.

First published 2007

Manufactured in the United States

ISBN 978.1.59629.217.8

Library of Congress Cataloging-in-Publication Data

Rajtar, Steve, 1951- A guide to historic Gainesville / Steve Rajtar.
p. cm.
Includes bibliographical references and index.
ISBN 978-1-59629-217-8 (alk. paper)
1. Gainesville (Fla.)--Guidebooks. 2. Streets--Florida--Gainesville--
Guidebooks. 3. Historic buildings--Florida--Gainesville--Guidebooks.
4. Historic sites--Florida--Gainesville--Guidebooks. 5. Gainesville
(Fla.)--Buildings, structures, etc.--Guidebooks. 6. Gainesville (Fla.)--History.
I. Title.
F319.G14R35 2007
975.9'79--dc222007000642

CONTENTS

INTRODUCTION

In the early 1850s, residents of Alachua County were certain of their desire to establish a new settlement to serve as their new county seat, but they weren't sure what to call it or where to put it. Choosing the name of Gainesville over Lewisville, and moving from their first chosen location about four miles to the northeast to higher ground, they took steps to create a new town with a bright future.

The town grew both in numbers and diversity of interests of commerce and industry, surrounded by cotton plantations and lumber-cutting and citrus groves. The arrival of the railroads made Gainesville a popular center of shipping for agricultural products, and it served as an important destination for travelers heading to Florida, especially those continuing on to the South to places that were not yet served by trains. Following the Civil War, Gainesville attracted a large number of black residents, reducing the white population to a minority.

Early in Gainesville's development, it earned a reputation as a center of education. Families both in the immediate area and from far away sent their sons and daughters to learn at the Gainesville Academy, which opened in 1856. After the end of the Civil War, it was merged with the East Florida Seminary, which had previously been located in Ocala. The Tebeau School and Chateau-Briant provided programs to turn youngsters into ladies and gentlemen. The Union Academy provided excellent education for black children beginning in 1866.

In 1906, what had been the Florida Agricultural College moved from Lake City and merged with the East Florida Seminary and several other institutions to form today's University of Florida. The university became involved in every aspect of the city, and each helped the other to grow in size and stature. The University of Florida has been a major force in research and has contributed important advancements in agriculture, science, medicine and almost every other area of human activity.

This guide is presented in two parts. The first will lead you through the decades of Gainesville's history with stories and images of many of the people, places and events that helped form and change the city and the university. The second will lead you up and down the streets of the city and the campus, with information regarding the sites you can still see as well as some that used to be there.

Gainesville and the University of Florida constitute an active center of higher education that continues to expand its national and worldwide reputation in many areas. The pages that follow track its growth and changes.

PART ONE:

HIGHLIGHTS
OF GAINESVILLE
HISTORY

THE 1810s

ARREDONDO GRANT

In December of 1817 Spain granted much of the land in and around today's Gainesville to Don Fernando de la Maz Arredondo, a merchant from Havana, Cuba, with the hope that he would settle there. The land previously included a Timucuan village and consisted of a square twenty miles on a side. The grant was made with the condition that its owners had to settle two hundred families there within the next three years. Arredondo himself never settled on his land, and he instead sold tracts to individuals who intended to reside there.

Don Fernando brought Horatio S. Dexter to the area to help establish friendly relations with the natives so settlement could be accomplished in a peaceful manner. Dexter brought with him Edward M. Wanton, who had lived with Indians for years. Within the square of the Arredondo Grant, Wanton set up a trading post that became the settlement of Micanopy. Moses Elias Levy bought 100,000 acres, including a part of the Arredondo Grant, and established the Pilgrimage Plantation near Micanopy to be a home for Jewish settlers. The area became an important center of commerce.

THE 1820S

ALACHUA COUNTY

In 1821, Spain ceded Florida to the United States. Alachua County was created three years later with a name that comes from the native word for "jug," likely referring to the sinkhole located within Paynes Prairie. The hole of its "jug" often filled with debris and the area turned into a large lake, which disappeared when the debris was occasionally sucked down into subterranean caverns.

As a condition of Florida becoming part of the United States, all Spanish grants were to be recognized. Legal challenges were made to the validity of the Arredondo Grant, and the issues were resolved by the Florida Supreme Court. It was discovered that the requirement of two hundred families settling there within three years had not been completely satisfied, but the court found that the actual number was close enough. The validity of the Arredondo Grant was confirmed.

HOGTOWN

Hogtown was a small Seminole village along what is now known as Hogtown Creek, near Gainesville's Westwood Middle School and the intersection of NW 34th Street and 8th Avenue. The location was favorable for agriculture, and white

HOGTOWN CREEK.

This scene of the Hogtown Creek area, northwest from today's downtown Gainesville, from about 1905 likely changed little over the previous several decades, except perhaps for the style of horse-drawn buggy crossing the bridge.

settlers who came to the area chose it for their log cabins, which they built near the homes of the Indians. In 1824, when Hogtown's white population was just fourteen, the Treaty of Moultrie Creek provided for payments to the Seminoles to "improve" their villages, meaning that they were to move out. Chief John Mico received twenty dollars in exchange for the Seminoles leaving Hogtown and moving to a government-established reservation.

One of the early plantations in the Hogtown Creek area was owned by Tillman Ingram. He also owned Oak Hall, considered to be the first house of importance in downtown Gainesville.

Some consider Hogtown to be the earliest name of what is now known as Gainesville. Most historians, however, consider them to be two separate communities, with Gainesville being the first and only name of the present city.

MICANOPY

Just to the south of Gainesville and Paynes Prairie is the city of Micanopy, which began as the trading post of Edward M. Wanton. He established his store there in 1821, and it attracted settlers who wished to homestead portions of the Arredondo Grant. When Dr. William Simmons was asked to help locate a site for the territorial capital, he traveled through Micanopy in 1822 and visited with Wanton. Simmons speculated that Micanopy would become the capital of Florida, and two years later the settlement, then named Wanton, was named the temporary county seat. All early important meetings in this part of the state were held at Wanton's store. Micanopy exists today as a quaint mecca for antique collectors and history buffs.

NEWNANSVILLE

The Newnansville Post Office was established in 1826 as Dell's Post Office, named for the brothers James and Simeon Dell who first went there in 1812–14. It was renamed in 1828 after a War of 1812 hero, Daniel Newnan. The Newnansville Post Office, with first postmaster W.L. Olmstead, in 1831 replaced the previous one operated by the Dells. Newnansville was on the route of the Bellamy Road, a federal road authorized by Congress in 1824 and used to carry mail from St. Augustine to Pensacola.

Also in 1824, Alachua County was created out of the giant Duval County. Newnansville was made the first permanent county seat of Alachua County in 1828, but when Columbia County was created in 1832, the county line was drawn to move Newnansville into Columbia

County. Three years later, the county line was redrawn and Newnansville was returned to Alachua County.

Newnansville's main products were cotton, corn and citrus. Moving the county seat to Gainesville in 1854 hurt the growth of the town, and its being bypassed by the railroad in 1884 signaled the eventual demise of Newnansville. It is now a ghost town with a cemetery and pair of historical markers.

The First White Settler

Bod Higginbottom is considered by many to be the first settler in what is now Gainesville, having arrived in 1825. He built a log cabin on what became Main Street, and it became a target for Indians who often tried to burn it down.

THE 1830s

FORT HOGTOWN

During the Second Seminole War (1835–42), Fort Hogtown was built near the Hogtown settlement to protect its white settlers. The men of Hogtown had organized a military unit, the Spring Grove Guards, combining with residents of the Spring Grove settlement about four miles to the west. The guards patrolled the area to protect the settlers from Indian attacks. The fort was more commonly known as Fort Walker, named for Captain Stephen W. Walker, a local volunteer killed by Indians in 1838.

FORT CLARKE

West of downtown on State Road 26 is the site of Fort Clarke, a Second Seminole War army post. Around it sprang up a small settlement near the military road that connected Newnansville, Spring Grove and Micanopy. The name Clarke came from a U.S. army officer.

THE 1840S

STATEHOOD

Prior to the Civil War, attempts were made by the U.S. Congress to admit states in pairs, consisting of one slave state and one free state, to keep a balance within the legislative branch. In 1845, it passed a law permitting the admission of Florida and Iowa as the newest states. However, despite Iowa having held a constitutional convention in 1844, it didn't become a state until 1848, after Florida and Texas. Florida officially became a state on March 3, 1845, with William D. Moseley as governor and David Levy Yulee as its first congressman.

Florida's constitutional convention had taken place in 1837, with a constitution adopted in January of 1839 by a narrow vote. Andrew Jackson wanted there to be two Floridas, as it had existed as two separate territories, but Northerners in Congress did not want two more slave states. As a result, the territories led by Pensacola and St. Augustine merged into a single state, and Tallahassee as roughly the midpoint in between was selected as the capital.

Early Florida was almost strictly agricultural, with an economy based on lumber, naval stores, cattle and various crops. Settlers began to arrive in Alachua County to farm and plant cotton.

THE 1850s

EAST FLORIDA SEMINARY

The Florida legislature in 1851 agreed to support two schools financially, one on each side of the Suwannee River. The sites were to be determined by the largest county commitments of land and resources.

Gilbert Dennis Kingsbury of Vermont (who changed his name to S.S. Burton and later to Francis F. Fenn) founded the East Florida Seminary (also known as the Kingsbury Academy) in 1852 in Ocala. The school ran short on funds and requested help from the state, which began to provide financial support on January 6, 1853, making it the sole state-supported school east of the Suwannee.

The date of the first state financial support is considered to be the beginning of the University of Florida, since the East Florida Seminary is the oldest of the university's several "parent institutions," which later merged. The Ocala school closed because of the Civil War, since the faculty and students of military age left to serve the Confederacy. After the end of the war, the school reopened in Gainesville.

In 1852, another East Florida Seminary was established by the Florida Conference of the Methodist Episcopal Church near the cemetery in Micanopy. Despite having the identical name, that school was unrelated to the one that had moved from Ocala to Gainesville, and the Micanopy school closed down in 1860 when Reverend John C. Ley left to become an army chaplain. Until that time, he served as the school's principal, teacher, financial agent and president of its board of trustees.

JAMES BAILEY

James B. Bailey moved to Alachua County in 1852 with his wife, four children and thirty-four slaves. He established a cotton plantation covering two thousand acres near Sweetwater Branch, a portion of which now makes up Gainesville's Courthouse Square.

BAILEY HOUSE.

James Bailey's home, completed in 1854 on his plantation, is Gainesville's oldest surviving house. It was constructed of locally grown longleaf pine, dressed in a mill along Hogtown Creek and built with slave labor with some Greek Revival architectural elements.

The family home was completed by 1854 with slave labor and longleaf pine, which grew on the Bailey property, processed at a mill along Hogtown Creek. The home consisted of four interior rooms with pine flooring and a stairway trimmed with wood from Florida red bay trees. The foundations and chimneys were constructed of coquina from St. Augustine. The home is still standing as Gainesville's oldest remaining house.

Bailey served as Gainesville's city treasurer and designed its jail. During the Civil War, he was a special messenger to Richmond, Virginia. Bailey died of meningitis while helping to construct army fortifications at Baldwin in Duval County.

KANAPAHA

This area west of downtown takes its name from the plantation established in 1854 by Thomas Evans Haile and his wife, Serena Chestnut Haile. They came from Camden, South Carolina, with their four children and sixty-four slaves. On 1,500 acres they grew sea-island cotton on a homestead they called Kanapaha, which may be Timucuan for "palmetto leaves" and "house." Slave labor built a 6,200-square-foot home in 1856.

HAILE STATION.

Thomas Haile's plantation was adjacent to the railroad tracks leading from Gainesville to Archer, facilitating the shipment of crops to market and the obtaining of supplies. This early 1920s photo shows the platform used for the Haile property.

They likely chose the site of the plantation based on David Levy Yulee's proposed railroad route from Fernandina to Cedar Key. Three of the Haile sons worked on the railroad, which the family used to take the short trip to Gainesville to visit friends and family and to bring them mail and supplies. They also depended on the trains to carry their crops to market.

The Haile home has been preserved for public tours at 8500 State Road 24 (Archer Road).

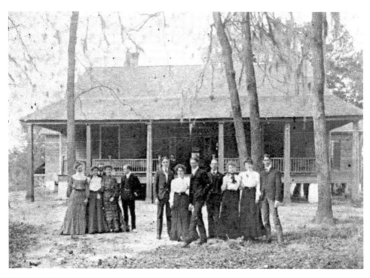

KANAPAHA PLANTATION.

Established in 1854 by the Hailes, the Kanapaha Plantation initially focused on cotton. About two years after settling there, they had their slaves construct the large home depicted in this 1903 photo.

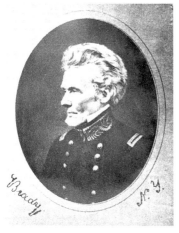

EDMUND GAINES.

This is a portrait of General Edmund Pendleton Gaines (1777–1849), after whom the city of Gainesville was named.

FOUNDING OF GAINESVILLE

The unincorporated town of Gainesville was created on January 24, 1854. With the establishment of schools and other industries it grew and served as a Confederate commissary during the Civil War. It also became a haven for people leaving coastal areas that were falling under Union control.

Its name had been selected by a vote of Alachua County citizens who showed up at a barbecue at Boulware Springs. Commissioner and influential planter William R. Lewis proposed that the town be named Lewisville after himself.

Instead, the county commission adopted the recommendation of William I. Turner, who proposed that it be named for General Edmund Pendleton Gaines, who had captured traitor Aaron Burr, participated in the initial 1817 battle of the First Seminole War and briefly commanded federal troops in the area during the Second Seminole War. In 1836, he commanded a contingent of soldiers headquartered at Fort Brooke. He and his men

were the ones who, seven weeks after the Dade Massacre, discovered the field of bodies and gave them proper military burials. Soon after, Gaines and his men were involved in heavy fighting in the Battles of the Withlacoochee and Fort Izard.

The name choice was made easy by an agreement reached with Commissioner Lewis, who cast his twenty votes in favor of a courthouse in the new town. He was promised that if the courthouse was not approved, the town would be named Lewisville. To his surprise, the move of the courthouse location from Newnansville was approved and the new county seat was called Gainesville.

FIRST METHODIST CHURCH.

This is an early photo of the Methodists' first sanctuary, constructed in 1874, converted to use as a social and lecture hall in 1887 and moved to another location in 1900 to be transformed into a private home.

METHODIST CHURCH

In 1854, the Methodist Society was formed by Reverend W.K. Turner and was later renamed the First Methodist Church. Its early services were held in the courthouse and the First Presbyterian Church. In 1874, a wooden sanctuary was built on the present church grounds along NE 1st Street. In 1887, it was converted to use as the congregation's social and lecture hall. In 1900, it was moved to 204 NE 3rd Avenue and modified to be a single-family residence.

DUDLEY FARM

During the 1850s, a farm was established by Captain Phillip B.H. Dudley west of downtown Gainesville, almost to Newberry. The original farm had 640 acres, and 325 acres remain with eighteen of the original buildings, all restored as a living history museum.

In 1862, Phillip Dudley formed a military unit in Gainesville. His company and that of Tillman Ingram saw action in Tampa and New Smyrna during the Civil War and combined in April of that year to be part of the Seventh Florida Regiment. Its members fought under General Braxton Bragg in Tennessee.

Unlike Kanapaha, the Dudley Farm was not close to the railroad. The town of Dudley had grown by the 1880s, and Captain Dudley had a store that served as the area's post office. Three generations of the Dudley family lived on and worked the farm for 124 years. Myrtle Dudley, Captain Dudley's last living granddaughter, donated the farm

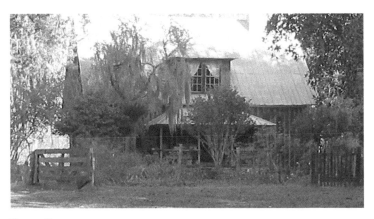

DUDLEY FARM.

The 1850s farm of Captain Phillip Dudley, now reduced to 325 of its original 640 acres, has been preserved by the State of Florida. The public may visit eighteen of its original buildings and see how the early Gainesville area settlers lived. *Photo by the author.*

to the Florida Park Service in 1983. She continued to live in the home until her death in 1996.

COURTHOUSE SQUARE

The site for the courthouse was chosen in 1854, after it was decided to move the county seat from Newnansville, based on a decision made the year before by an assembly that met at Boulware Springs. Those in attendance wanted to have the county seat close to the planned Fernandina-Cedar Key Railroad. At the time, the town covered the area from Sweetwater Branch west to SE 2nd Street, and from SE 2nd Place north to NE 5th Avenue.

1854 COURTHOUSE.

When the county seat was moved from Newnansville to Gainesville in 1854, W.L. and Mike Finger were hired to construct this wooden courthouse. Animals were allowed to roam the grounds and often distracted court proceedings and county business.

The county commissioners bought 63.5 acres from Major James B. Bailey and 40 acres from the estate of Nehemiah Brush. They platted a town with forty-foot-wide streets, except for those entering Courthouse Square, which were ninety feet wide. The square was formed by what are now University Avenue, Main and SE 1st Streets and SW 2nd Place.

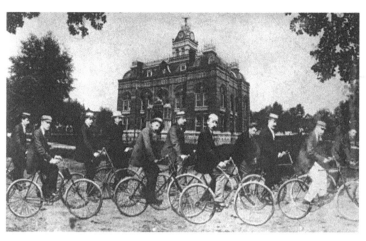

1884 COURTHOUSE.

This photo from the 1890s shows the local bicycle club in front of the second Alachua County Courthouse, constructed in 1884. The brick structure stood until 1962, when it was removed so that the third courthouse and its grounds could be completed.

1958–62 COURTHOUSE.

This is a 1971 photo of the Alachua County Administration Building, which previously served as the Alachua County Courthouse. The lower section along University Avenue was completed in 1958 and the taller one along SE 1st Street opened in 1962.

The first courthouse erected on the square was a frame building contracted by Tillman Ingram in 1856 at a cost of $5,500. The box-like two-story structure had porches jutting out from doors on all four sides. Two-and-a-half-foot-tall rock pillars held up the structure of white clapboard. It opened for business on December 8, 1856. Gainesville's first streetlights were installed on Courthouse Square in 1877. In 1882, John Varnum laid a brick sidewalk around the square. The old streetlights were converted to electricity in 1915.

In 1884, the wooden courthouse was replaced by one made of red brick that cost $50,000. Its clock tower was surmounted by a sculpture of a flying eagle. The eagle and mansard roof were later replaced because the roof leaked. Initially, the courthouse was surrounded by an iron fence to keep out pigs, chickens and dogs that had disrupted court business in the earlier structure.

That building was replaced by one costing $1,100,000, located on the opposite side of SE 1st Street (with the long axis of the building

running parallel to University Avenue) in 1958. The 1884 brick courthouse remained until the second phase of the new complex, completed in 1962 parallel to Main Street, was built. The 1962 structure became the County Administration Building in 1976, upon the opening of the fourth courthouse.

BLACKJACK RIDGE

When Gainesville was founded, the first suggested site for the town center was at Sugarfoot Prairie, near the present site of Butler Plaza and close to Interstate 75. In 1854, the preferred location was shifted to Blackjack Ridge, a high and dry area in a blackjack oak forest near Sweetwater Branch. The first passenger train came to Blackjack Ridge on April 21, 1859, but the settlers had miscalculated and the tracks came through six blocks from the center of town. Temporarily, passengers and freight were carried from Courthouse Square to the depot on a horse-drawn streetcar.

GAINESVILLE ACADEMY

In 1856, James Henry Roper came to Gainesville from North Carolina in an attempt to recover from the devastating effects of tuberculosis, which had threatened his life. Two years later, he established the Gainesville Academy on a city block purchased from the county for

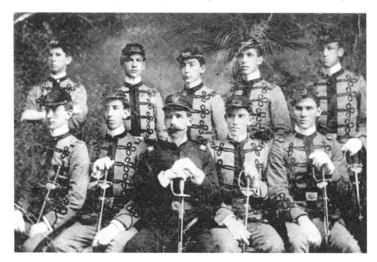

GAINESVILLE ACADEMY CADETS.

The Gainesville Academy had both male and female students who attended classes. The males wore military-style uniforms, were awakened by a bugler and marched in formation when heading from one class to another.

five dollars. He erected its building on NE 1ˢᵗ Street and served as its first principal. By 1866, it grew to an enrollment of sixty-five boys and girls with three teachers.

Roper, a state senator, offered the state his school and the land on which it was located if the East Florida Seminary were moved from Ocala to Gainesville. The state accepted the offer, and the school moved from Ocala following the Civil War and merged with the Gainesville Academy. Edwin P. Cater of South Carolina became the principal of the combined school (called the East Florida Seminary) in 1877, when the ages of the students ranged from four to twenty. He imposed age limits (minimum thirteen, maximum twenty) and instituted a mandatory entrance examination that all students had to pass.

EVERGREEN CEMETERY

In 1856, a private cemetery was established southeast of downtown. It became city property in 1944 and remains as Gainesville's only municipal cemetery.

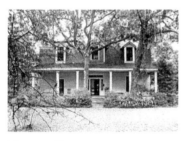

MATHESON HOUSE.

This photo shows the 1857 home of Alexander Matheson and his family, following the additions and modifications through 1907, which included the new mansard roof. It fronts on Sweetwater Branch and a park containing display panels explaining Gainesville's history.

THE MATHESON FAMILY

Alexander Matheson moved his family to Gainesville from Camden, South Carolina, in 1857 and built a modest farmhouse along Sweetwater Branch. The Mathesons moved back to South Carolina during the Civil War. Alexander's younger brother, James Douglas Matheson, who had served as an officer in the Seventh South Carolina Cavalry under Robert E. Lee, then acquired the property. He and his wife, Augusta Florida Steele, moved in.

James rebuilt the home, incorporating parts of his brother's house, and by 1907 added a gambrel roof, bedrooms on the second floor, a first-floor sitting room and gabled dormers. He also enclosed part of the back porch. James became a prominent local merchant and served as the county treasurer, county commissioner and trustee of the East Florida Seminary.

This was also the home of Reverend Christopher Matheson, who served eight terms as the mayor of Gainesville (1910–18) and also was a member of the Florida Legislature in 1917 and 1919. He left his

Gainesville law practice in 1919 to be a minister in Oklahoma. He remained there until 1946, when he moved back to Gainesville. His widow, Sarah Hamilton Matheson, donated the house to the historical center in 1989.

The frame house is constructed of heart pine on brick piers, with six free-standing wooden columns that rest on the ground. Cypress shingles are cut into decorative shapes. The unusual gambrel roof has three standard narrow dormers topped with low-pitched gables, giving this home a collection of elements of Dutch Colonial, Gothic and South Carolina Plantation styles. The surrounding land was formerly occupied by an orange grove.

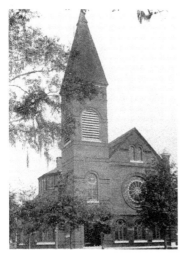

FIRST PRESBYTERIAN CHURCH.

After sharing its first wooden church building on E. Main Street with other denominations for thirty years, the First Presbyterian Church constructed this Gothic-style sanctuary in 1890. It served the congregation until the present church was completed in 1954.

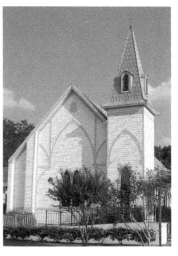

KANAPAHA PRESBYTERIAN CHURCH.

This church was founded by cotton farmers and their 1859 sanctuary is still in use. The congregation was the parent of the Presbyterian church in Gainesville, both in helping it organize and in providing members who moved toward downtown from this outlying area. *Photo by the author.*

FIRST PRESBYTERIAN CHURCH

During the 1850s, cotton farmers from South Carolina settled in the area near present-day Archer Road and established a church. In about 1857, they brought Reverend William McCormick to the area to undertake mission work, and he rode a circuit that included Gainesville, Cedar Key, Ocala and Micanopy. Through his efforts, churches were founded in Micanopy, Orange Creek, Archer, Flemington, Wacahoota and other communities.

The church closest to Gainesville was known as the Kanapaha Church, founded in April of 1859, which began losing its membership as Gainesville grew and enticed settlers to move closer to downtown.

First Presbyterian Church formally organized on March 23, 1867, as a branch of the Kanapaha Presbyterian Church. A Presbyterian sanctuary had been opened on SE 1st Street on December 1, 1859, and was shared with the Methodists, Episcopalians and Baptists, but formal organization of First Presbyterian Church was delayed for years by the Civil War. In 1890, the Presbyterians built another sanctuary at 234 W. University Avenue. The congregation then moved to a new church building at 300 SW 2nd Avenue, completed in 1954.

THE 1860s

POPULATION

As the 1860s opened, Gainesville's white population numbered 223. There were many black residents, especially on the outlying plantations and farms. The Haile Plantation itself had almost 100 black slaves.

GAINESVILLE MINUTE MEN

In 1858, Florida Governor Matthew Starke Perry called for a reorganization of the state militia in case war might break out, but it was not imminent enough to motivate the local men to take action. When abolitionist John Brown in 1859 seized the federal arsenal at Harpers Ferry, (now West) Virginia, the local Alachua County men felt it was time to act and the Gainesville Minute Men formed. After the Civil War broke out, the contingent from Gainesville became a part of the First Florida Regiment. Soldiers from Gainesville saw action on many battlefields.

Gainesville was strongly in favor of Secession, largely because of its high percentage of settlers from South Carolina, the state most opposed to preserving the Union. Gainesville residents did not have many slaves, but did not want to have their lives dictated by the North. The area's economic stability was also dependent upon cotton, which itself relied on slave labor.

SECESSION

On January 3, 1861, a General Assembly convened in Tallahassee in the halls of the Florida House of Representatives to consider the secession of Florida from the United States. Alachua County was represented by Dr. John C. Pelot of Micanopy and Judge James Baird Dawkins from Gainesville. It took only two days to draft an Ordinance

of Secession, which was adopted by the assembly on January 10, 1861. It declared Florida to be a "Free and Independent Nation."

Florida briefly remained independent, although aligned with the other states that had seceded, until the formation of the Confederate States of America. Montgomery, Alabama, was the meeting place for delegates from Florida, Alabama, South Carolina, Georgia, Mississippi and Louisiana. They began meeting on February 4, 1861, and by February 9 had signed a provisional constitution. That was superceded by a final constitution, adopted on March 11, 1861. Florida was readmitted to the Union on June 25, 1868.

Civil War Encounters

Because of its central location, Gainesville was believed to be relatively immune from an attack by the Union army. Cattle herds from south Florida were moved to Paynes Prairie and the city served as a food depot for much of the Confederacy east of the Suwannee River. Fort Lee was erected just east across Sweetwater Branch. It was not felt to be necessary to construct a fortification to protect the town, so it was merely a small post that served as a gathering place for volunteers.

On February 15, 1864, near the intersection of University Avenue and Main Street, a Federal raiding party of forty-nine soldiers of the Fortieth Massachusetts Cavalry led by Captain G.E. Marshall followed the railroad tracks and entered Gainesville in an attempt to capture two trains. They briefly held the Suwannee Hotel at the northwest corner and barricaded the four roads with cotton bales. At the intersection, they were met by twelve to twenty-four members of the Second Florida

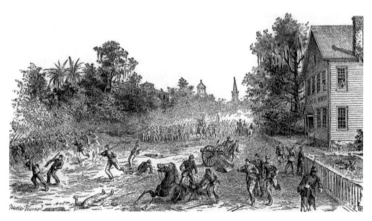

Second Battle of Gainesville.

This is an artist's rendering of the battle that occurred on August 17, 1864, near the Beville House, and not far from the railroad depot and the site of today's power plant. The Union soldiers suffered substantial casualties and were driven from the city.

Cavalry, which had been camping in Newnansville. The Confederates were repulsed, and when they returned the following morning they found that the Union soldiers had left the area. The encounter is known as the First Battle of Gainesville.

On August 17 of that year, the Florida Cavalry led by Captain John Jackson Dickison attacked approximately three hundred Union occupation troops near the Beville House hotel not far from the railroad depot. The Union soldiers led by Colonel Andrew T. Harris were driven from Gainesville following a fight and pursuit by the men commanded by Dickison, called "Florida's most conspicuous soldier." The Second Battle of Gainesville resulted in fifty-two Union soldiers killed and about three hundred wounded, and the Confederates had eight casualties.

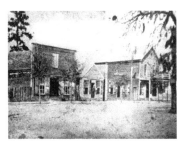

EARLY BUSINESS DISTRICT.

The earliest stores to the west, north and east of Courthouse Square were made of wood, the preferred building material for decades. Shown in this photo are the store of Chris Matheson, the medical office of Dr. James McKinstry, the post office and the Vidal Drug Store.

EARLY BUSINESS DISTRICT

The north-south streets bordering on each side of Courthouse Square, plus the stretch in between of Alachua Avenue (now known as University Avenue), composed the business district of early Gainesville. One of the earliest stores was opened on the east side of Courthouse Square in August of 1865 by George Savage and Edward Haile, who sold dry goods, tinware, shoes, hardware and other items. They accepted payment in money and "products of the country."

BLACK RESIDENTS

Following the Civil War, many black soldiers remained in Gainesville, including a contingent that camped along the east side of NE 1st Street. The all-black Third Regiment of the United States Colored Troops remained in the city for several months, and that encouraged newly freed slaves to settle in Gainesville. As a result, the city soon had more black than white residents. Many settled in an area now known as the Pleasant Street Historic District, bounded by NW 1st and 6th Streets and NW 1st and 8th Avenues.

THE NEW ERA

On July 8, 1865, the *New Era* newspaper began publication. It was edited by J.M. Arnow and William H. Robertson, who espoused a temperate manner and democratic principles. The contents of the paper were censored by the occupying soldiers until the publishers were able to obtain an order late in 1865 from the commander of the Military Department of Florida allowing them to print whatever they wanted.

UNION ACADEMY.

When the Union Academy opened for the black children of Gainesville, the biggest obstacle was the resistance of the white boys who attended other schools. They threw objects into the classrooms, both at the black students and the white teachers.

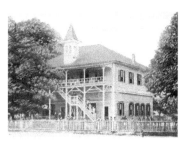

UNION ACADEMY.

Following Reconstruction, funds continued to arrive from the North, enabling black students to receive a quality education. This photo shows the academy building after the 1890s addition of a second story.

UNION ACADEMY

In January of 1866, the Bureau of Freedmen, Refugees and Abandoned Lands (Freedmen's Bureau) established the Union Academy to help it accomplish its goal of educating freed slaves. The academy's board of trustees was formed of local black leaders, and they purchased the land from the estate of Nehemiah Brush. The school at the southwest corner of NW 1st Street and 7th Avenue began in 1867 with 175 black children in grades one through ten and was supported by the George Peabody Fund, then by the Board of Public Instruction. The cost of the one-story building was $6,000.

The first teachers were white and came from Northern states, and were often the targets of insults and objects thrown by local white citizens who opposed the education of black children. Local black teachers were added after the school had been in operation for about a decade. Traditional academic subjects were taught, along with thrift, industry, sobriety and order.

After Reconstruction, financial support continued to come from Northern states. This money allowed the Union Academy to have a longer school year and better paid

teachers than were found in the white schools. The school expanded to cover the elementary and high school levels and during the 1880s added a normal school.

The academy grew with the addition of a second story and had about five hundred students by 1898, and many local black teachers received their education there. It grew to eleven classrooms and eleven teachers. The last principal was A. Quinn Jones, who served from 1921 until 1925, when the school building was converted to a recreational center. During the 1930s, it also served as a home for elderly men. It was later torn down.

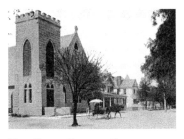

HOLY TRINITY EPISCOPAL CHURCH.

Shown on this 1908 postcard is the Gothic Revival stone church begun in 1905 to house the Holy Trinity congregation. The building looks the same today, as it was rebuilt with the same appearance following a devastating 1991 fire.

HOLY TRINITY EPISCOPAL CHURCH

In 1860, Reverend O.P. Thackara of Fernandina started an Episcopal mission in Gainesville, and by 1868 its membership consisted of five families. In 1873, they built their first sanctuary on the lot of the present Masonic Temple, 215 N. Main Street. The church was made of wood with a Gothic style.

The cornerstone of the present Holy Trinity Episcopal Church

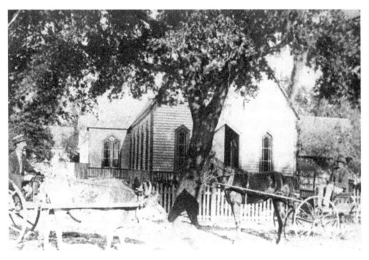

FIRST EPISCOPAL CHURCH.

This was the first Episcopal church building erected in Gainesville, and was located at 215 N. Main Street, the site of the present Masonic Temple. The church was built in 1873 and was used until a new sanctuary was completed on another site in 1907.

at 100–110 NE 1ˢᵗ Street was laid in 1905 by Bishop Edwin Weed. The church was designed by Jacksonville architect J.W. Hawkins with a Gothic Revival style and its cost was $25,000. Although incomplete, the building hosted its first service in 1907.

In 1991, the beautiful Ascension stained-glass window was removed from the church for repair. While it was out, the church suffered a devastating fire on January 21, 1991, which destroyed most of the building. The congregation rebuilt it to look like it had before the fire, and reinstalled the original stained-glass window. Its first service in the rebuilt church was held on Easter Sunday in 1995.

INCORPORATION

Gainesville was incorporated on April 15, 1869, and S.Y. Finley became the town's first mayor. The Gainesville Police Department was formed with P. Shemwell elected as the town's first marshal. The position of head of the department was continued as marshal until 1919, when the title was changed to chief of police. However, the chief had no subordinates to lead, since after fifty years of law enforcement the department still consisted of only one man.

JEWISH SETTLERS

The first Jewish family, including Moses Endel, moved to Gainesville during the late 1860s. The Endels came here from Virginia and opened a store at the corner of Main Street and University Avenue. Jewish families in 1872 established a cemetery, which remains at the corner of University Avenue and Waldo Road, with the first burials taking place during the 1870s. Included are the graves of an entire family wiped out by the yellow fever epidemic in 1888. The first Jewish congregation formally established in Gainesville incorporated during the 1920s as Congregation B'Nai Israel, meaning Brothers of Israel, and built a synagogue in 1924 at the northeast corner of SW 2nd Place and SW 2nd Terrace. That corner is now an empty lot, with much of Gainesville's Jewish population being served by the B'Nai Israel Jewish Center at 3820 NW 16th Boulevard.

THE 1870s

FIRST BAPTIST CHURCH

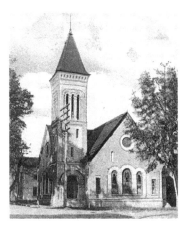

FIRST BAPTIST CHURCH.

This image comes from a postcard mailed in 1906, and shows the First Baptist Church sanctuary that had been constructed a decade before. The Baptists continued to use it until they built their present sanctuary in 1923–24, and it was converted to use by the First Christian Church.

On August 14, 1870, Thomas C. Ellis chaired a group to organize a Missionary Baptist church. What resulted was the First Baptist Church of Gainesville with twenty-one charter members, led for a short time by Reverend John Henry Tomkies. They completed their first sanctuary in June of 1875 at the southeast corner of Main Street and SE 2nd Avenue, helped by a loan from the Baptist Home Mission Society. Reverend Tomkies was succeeded by Reverend C.V. Waugh in 1876.

Another church was built in 1896–97 at the northwest corner of University Avenue and NE 2nd Street. It hosted its first service on April 3, 1897, and its official dedication occurred on January 25, 1903. That church was superseded by another in 1923–24 on two lots at 425 W. University Avenue, constructed with a Classical Revival architectural style. The first service in the new sanctuary was held on September 14, 1924. At the time, it occupied two city lots with a frontage of 190 feet along University Avenue and extended southward 300 feet. The cost of the building was approximately $150,000.

The 1897 building was sold to the First Christian Church, which held services there until 1949, when the congregation built a new church elsewhere. The 1897 church was then acquired by Cicero Addison Pound, who had it demolished in the late 1950s, except for its tower.

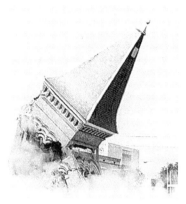

BAPTIST CHURCH TOWER.

After the main portion of what had been the First Baptist Church was demolished in the late 1950s, its tower remained as a local landmark across from Courthouse Square. This photo was taken on July 12, 1965, as the tower was torn down.

That remained until the land was needed for the new city hall and library. The solitary tower for years provided a name for Baird's Tower Parking Lot and Alford's Tower House Restaurant, which were also removed when the tower was brought down in 1965.

JOSIAH WALLS

After service in the Civil War, first for the Confederacy and then as a member of the Federal United States Colored Troops, Josiah T. Walls married Helen Ferguson and moved to Alachua County. He served as a state representative and senator and won a hard-fought race to be a member of the U.S. House of Representatives.

In 1870, Walls moved from Newnansville to Gainesville and lived near the intersection of University Avenue and SW 2nd Street. In 1873, he purchased a plantation of 1,175 acres near Paynes Prairie and bought the *New Era*, a weekly newspaper. He also became a member of the Florida Bar. After serving as Gainesville's mayor, a county commissioner and a member of the Board of Public Instruction, he moved to Tallahassee to be a farm director at what is now Florida A&M University.

TEBEAU SCHOOL

In 1873, Miss Maggie Tebeau's Boarding and Day School was founded by Margaret "Miss Maggie" Tebeau of Virginia and her friend, Sarah Caroline Morrison Thomas. It opened on the north side of University Avenue across from Courthouse Square, then moved to an entire city block on S. Main Street two blocks from the square (the site of the 2003 courthouse). Shade at the school was provided by large water oaks.

Maggie Tebeau disagreed with the beliefs of many that competition among young ladies rendered them less feminine. On the grounds of her school, she installed tennis courts and encouraged her female students to engage in the sport.

Over more than seventy years, the school educated young ladies and gentlemen and was known for its large gardens with flowering

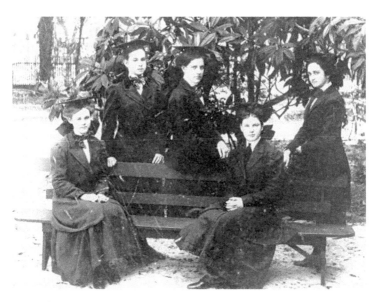

TEBEAU SCHOOL GRADUATES.

Boys attended day classes at the Tebeau School, but for girls it was a boarding school. This portrait of some of the female graduates includes Kate Clyatt Trenton on the left and Annie Pound on the right.

MARGARET TEBEAU.

Shown here is "Miss Maggie" Tebeau who, with Sarah Thomas, founded a private school in 1873 that achieved a reputation of turning girls and boys into ladies and gentlemen. The school continued in operation on South Main Street for twelve years after Miss Maggie's 1924 death.

shrubs. Approximately ten to fifteen girls lived at the boarding school, and boys attended day classes. In 1909, it was declared as the diocesan school for girls of the Florida Diocese of the Protestant Episcopal Church.

Maggie Tebeau died in September of 1924, and the operation of the school was taken over by her niece, Alice Thomas. The school closed in 1936 and the Holy Trinity Episcopal Church used the building for the Tebeau Nursery School until 1948. Alachua County purchased the building in 1949 and tore it down in 1951.

PRESIDENTIAL ELECTION

Leonard G. "Little Giant" Dennis of Massachusetts was active in local Republican politics. He pushed for black residents to vote,

L.G. DENNIS.

This portrait of L.G. Dennis of the Massachusetts Volunteers was taken during the Civil War a few years before he moved to Gainesville and became a powerful political force, getting his candidates elected without the formality of their actually receiving valid votes.

making the black majority a strong force in Alachua County. Also, if anyone wanted to hold public office, they generally had to pay Dennis a fee, and he kept in his possession signed resignation letters that he could use when public officials no longer wanted to follow his dictates.

His most famous exploit involved stuffing the ballot box for the 1876 general election in his home office at 324 NE 1st Street. The vote count at the end of the day in Archer was 180 for the Republican candidate and 136 for the Democrat. The tally sent to Tallahassee, however, was 399 Republican, 136 Democrat. The ballot box had been brought to the Dennis house from Archer and, during the night in a room supplied by him, it is believed that the additional votes were placed in the box by Thomas H. Vance and Richard H. Black. Despite challenges, the Republican presidential candidate, Rutherford B. Hayes, defeated Democrat Samuel Tilden, based on a slim Republican margin reported late from Florida.

NEWSPAPERS

On July 6, 1876, the *Gainesville Times* was founded as a Democratic newspaper. It was renamed the *Gainesville Sun* in 1879. That was also the year Henry Hamilton McCreary moved to Gainesville and began publishing the *Weekly Bee*. It later consolidated with the *Sun* and for a time, the newspaper was known as the *Gainesville Sun and Bee*. It was renamed the *Gainesville Daily Sun*. In the 1890s it was published as a daily morning paper from an office on North Main Street, edited by McCreary, who supported the university's move to Gainesville.

THE 1880s

RAILROADS

Senator David Levy Yulee promoted the construction of a railroad from Fernandina to Cedar Key, passing through Gainesville. It connected at each end with ocean ports that could be used to ship goods to New York and New Orleans. The Florida Railroad was in use in the 1850s, and its presence was an important factor in the locating of Gainesville.

Debate raged throughout the Civil War as to whether the railroad tracks in Florida should be taken up. On the one hand, trains were necessary to ship cattle and other foodstuffs to the rest of the South. On the other, it was feared that the Union forces could capture the

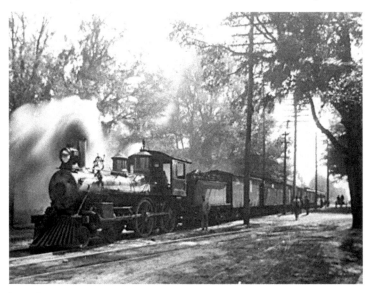

STEAM LOCOMOTIVE.

With several railroad lines passing through or near Gainesville, it became a major center for both passenger and freight traffic. This is an early photo of steam engine #555 of the Atlantic Coast Line Railway in Gainesville.

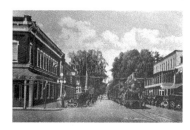

RAILROAD TRACKS.

This image from the 1920s shows the main passenger rail route through Gainesville—along Main Street. The tracks shared the street with horse-drawn carriages, and then automobiles, until shortly after World War II.

railroad and use it to hurt the Confederacy. A portion of the tracks were taken up at the eastern end of the line, then were relaid after the end of the war.

The Florida Railroad was reorganized as the Atlantic, Gulf and West India Transit Railroad in 1872. In 1881, the name was shortened to the Transit Railroad. Two years later, it became the Florida Transit and Peninsular Railroad, and in 1884 was part of the Florida Railway and Navigation Company. In 1888, it became a division of the Florida Central and Peninsular Railway.

Beginning in the 1880s, the railroads began to expand. An 1881 extension connected Fernandina with Jacksonville. A line from Gainesville to Palatka in 1881 connected Gainesville with south Florida and Cincinnati along the Florida Southern Railway, which by 1902 was a part of the Atlantic Coast Line Railroad. The Gainesville and Gulf Railway Company in 1895 built a line connecting Gainesville to Micanopy, which was later extended to Irvine and Fairfield.

Most of the land for the railroads was cleared by black laborers, often slaves or prisoners. After the tracks were laid and the trains were placed in service, they were maintained by the Gandy Dancers, gangs of workers named for the Gandy Company, a manufacturer of their tools.

Adolph Vidal

Dr. Adolph J. Vidal, a graduate of the Charleston Medical College, came to Florida for his health in 1881 and opened a drugstore on the north side of Courthouse Square. He succumbed to tuberculosis in 1905 and the Vidal Drug Store was taken over by his son, Adolphe L. Vidal.

The family also owned Vidal's Groceteria and had a publishing business that printed postcards. Many of the images we have of early Gainesville are preserved on postcards printed by A.L. Vidal & Co.

Discovery of Gold

The land at the southwest corner of University Avenue and SW 2nd Street was the site of the town's first public school classes. Later, it

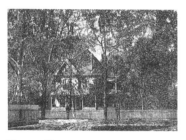

DUTTON HOUSE.

In the early 1880s, gold was discovered beneath this yard along W. University Avenue. The precious metal is still there, 190 feet below the surface, but the cost of bringing up and processing the ore would greatly exceed the value of the final product.

was the site of the home of Dr. Babcock, followed by the family of Henry F. Dutton.

During 1882 and 1883, the city attempted to drill an artesian well on Courthouse Square to provide water, but abandoned the project when the drill bit broke at a depth of 180 feet. At 176 feet, the drillers had hit gold-bearing ore, as confirmed by an assay report. The drilling equipment was then moved to the Dutton property with the hope that the ore might again be reached.

At 190 feet, they found the ore, but an assay report based on a sample sent to Harvard University estimated that it would only yield $4.16 of gold for every two thousand pounds of ore. Since that exceeded the cost of mining it, the project was abandoned. What resulted was an artesian well that irrigated a beautiful garden on the Dutton property.

FIRE DEPARTMENT

In 1882, a volunteer fire department was formed, and Gainesville's residents and businesses provided fire-fighting equipment. Leonard G. Dennis provided the first fire engine, a pumper operated by fifteen to twenty men.

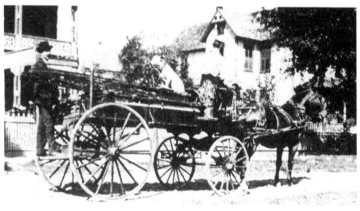

FIRE DEPARTMENT.

One of the early chiefs of the volunteer fire department was John MacArthur. The horse in the photo might be one of the department's first three, all named for the chief—John, Mac and Arthur.

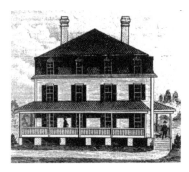

CHATEAU-BRIANT.

According to their advertising, Mr. and Mrs. Eastman's private school followed the traditions of schools in France and England, and had students from kindergarten through high school. Boys attended during the day, and girls also lived upstairs.

CHATEAU-BRIANT

From the beginning, Gainesville has been known as a center of education, especially for its fine private schools. During the 1880s, one well-known school was that of Mr. and Mrs. J.C. Eastman. Known as the Chateau-Briant, it was located on NW 9th Avenue (then known as Gordon Street) in a large (forty-two-by-forty-seven-foot) three-story house.

The boarding school had a parlor and classroom on the first floor, used for examinations and entertainment, plus rooms for the kindergarten department and another for older students. Upstairs were eight dormitory rooms for female students, plus another for the female teachers. It was advertised as a French and English school for young ladies and children. Laura E. French taught music, and other classes included Latin, Greek, modern languages, drawing, painting, housekeeping, sewing and embroidery. Mr. Eastman also was a dealer in stationery and periodicals.

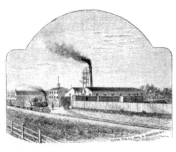

COTTON GIN.

This etching depicts the first substantial buildings of Gainesville seen by passengers arriving at the depot near S. Main Street. From the 1870s, the H.F. Dutton Company processed cotton for shipping to textile mills located elsewhere.

COTTON

During the 1880s, Gainesville was Florida's largest producer and shipper of sea-island cotton. The H.F. Dutton Company alone handled one-fourth of all cotton grown in the state. Its cotton was shipped to the Willimantic Thread Company in Connecticut and other textile companies with strong reputations. The Dutton buildings were located near the railroad depot and the cotton ginneries were the first impressive structures seen by travelers arriving by train from Cedar Key.

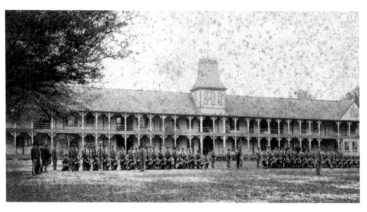

EPWORTH HALL.

This large wooden dormitory provided living space for male East Florida Seminary students and instructors. This photo was taken in 1903, about eight years before the building burned down. In its place is the northern end of today's Roper Park.

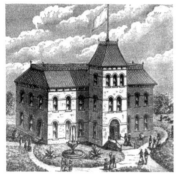

EFS DORMITORY.

This nineteenth-century engraving depicts Epworth Hall when it was new, serving students of the East Florida Seminary with a main entrance through the tower along the south side of the building. Now, the main door is to the west along NE 1st Street.

EAST FLORIDA SEMINARY

The East Florida Seminary initially consisted of a single building, which burned down in 1883. It was replaced by Epworth Hall, a new $13,000 two-story brick building used both for classrooms and administrative offices. On the north end of the campus was built a large wooden dormitory, 197 feet long and 90 feet wide. Beds had iron frames and mattresses stuffed with moss. Male teachers lived in fourteen of its rooms. A separate building housed the kitchen, infirmary and bathrooms.

Seminary students were prohibited from going into town at will, or from hanging around the post office, railroad station or hotels. They were prohibited from using malt or liquor, playing pool or billiards, possessing firearms, reading unapproved books or papers, using profane language, gambling or using tobacco. For the male students, it was a military school complete with uniforms, bugle wake-up calls and dinner in the mess hall. They marched in formation to their classes.

The Seminary merged into the University of Florida and university classes began in Epworth Hall in 1906. In 1911, the building was sold to the First Methodist Church, and it remains at 419 NE 1st Street. Not

long afterward, the wooden dormitory burned down. The school's campus was turned into a city park, named Roper Park for the founder of the Gainesville Academy.

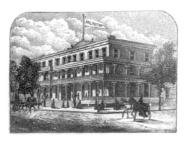

ARLINGTON HOTEL.

This artist's rendering of the stately Arlington Hotel shows its appearance during the 1880s on the northwest corner of University Avenue and Main Street. It likely was the victim of arson, bringing attention to the wisdom of building with brick instead of wood.

ARLINGTON HOTEL

During the early 1880s, the northwest corner of University Avenue and Main Street was the site of the three-story Arlington Hotel, built by J.O. Goodale. Since Gainesville was then the southernmost limit of passenger travel by train, it served as a stopping-over place for those who might then switch to travel by foot, wagon or stagecoach. It could accommodate two hundred guests.

Those on the second-floor verandas had a good view of Courthouse Square. Before dawn during May of 1884, a fire broke out in the Varnum Hotel, located across University Avenue on the corner of S. Main Street and SW 1st Avenue. The fire quickly spread to businesses on the west side of the square.

A fire also broke out in the Arlington Hotel hours later. Later that same day, someone broke into a livery stable, let the horses out and soaked the hay with turpentine. He was run off before he could light it. Some suspected that all three incidents were related. The destruction of the wooden Varnum and Arlington and the blocks on which they stood motivated the citizens of Gainesville to switch from wood to masonry as their preferred building material.

GAINESVILLE GUARDS

This home guard unit of the state militia formed by the mid-1880s included several of Gainesville's socially prominent men. They wore decorative uniforms with sashes across their chests. Weapons included javelins and lances, which were inserted into sockets on their saddles at stirrup level. They were called into action much the same way as today's National Guard is utilized, only at a more local level. The organization also served social functions and held minstrel and other theatrical shows and dances to raise money for worthy causes.

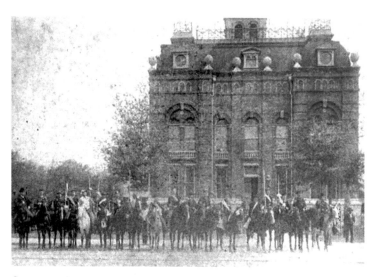

GAINESVILLE GUARDS.

Members of the local military unit pose in front of the newly completed Alachua County Courthouse in 1884 or 1885. The guards, mostly from prominent families, were often armed with lances and javelins.

FIRST PUBLIC SCHOOL BUILDING

William N. Sheets, the city's superintendent of public instruction, began a campaign in 1892 to establish a good public school. Previously, public education in Gainesville had lacked appropriate buildings, books, materials and heat. Because of his urging, taxpayers finally agreed to provide some financial support.

Gainesville's first public school building, known as Gainesville Public School No. 26, was built in 1885 at approximately 407 E. University Avenue, just west of Sweetwater Branch. A wooden bridge was built over the stream, extending the road eastward. Later, the two-story building was used as a laundry and then by Colonel Ada Burton as a home for indigents.

ST. PATRICK'S

Catholic Masses began to be celebrated in Gainesville starting in 1862, with many of the early services taking place in the home of James Battle. After Battle died, the Catholics moved to the city hall. A visiting priest held Mass in 1879 and in 1881 Masses were held on a regular basis. They took place in the Flynn home and Young's boardinghouse, and then in 1887 St. Patrick's Catholic Church was constructed on NE 1st Street. Father Patrick Lynch was installed as the first parish priest.

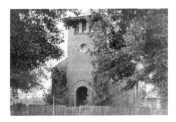

ST. PATRICK'S CHURCH.

The first Roman Catholic church building was constructed in Gainesville after twenty-five years of holding Masses in temporary locations, including private homes. This is a photo of the church erected in 1887 on NE 1st Street.

In 1976, the original 1887 cornerstone and frieze were mounted outside the door to the present church building at 430 NE 16th Avenue.

YELLOW FEVER

In 1888, a strike of longshoremen in Fernandina resulted in riots, and the Gainesville Guards were sent there to keep the peace. The wife of the leader of the strikers was ill, and some of the soldiers protecting the family had contact with her. They became sick, and a doctor from Gainesville went to Fernandina and reported that the illness was not yellow fever, a potentially fatal disease noticed earlier that year in Tampa that was spreading northward. On September 11, the men returned to Gainesville and, although some were ill, their symptoms were attributed to exhaustion.

BAIRD THEATER.

A dominating sight near Courthouse Square is the large Baird Theater, erected in 1887 as the Simonson Opera House. There are still retail establishments and offices on the lower floors, but no longer are there live shows and movies upstairs.

Five days later, it was announced that their illness was indeed yellow fever. Many residents left the town, and the perimeter of Gainesville was guarded to prevent people from entering. Trains and the mail were halted. On December 4, it was announced that the outbreak was over. In the town, there had been 116 cases reported and 16 deaths (including Gainesville Guards Lieutenant Elam A. Evans and Sergeant M. Fitch Miller).

THE 1890s

PAYNES PRAIRIE

Much of what is now a state preserve was formed through the prehistoric settling of land as the underlying limestone dissolved, forming the Alachua Sink. On top is now marsh and wet prairie vegetation, with some open water.

The area was the home of prehistoric natives and the seventeenth-century Spanish La Chua cattle ranch. In 1774, William Bartram called it the Alachua Savanna and described it as being "the most sudden transition from darkness to light, that can possibly be exhibited in a natural landscape." It is named for Seminole Chief King Payne, who assumed the leadership of the Seminoles after the death of his father, Cowkeeper, during the 1780s.

The prairie occasionally filled with water, and a notable 1867 flood killed many sheep and cattle grazing there. The water receded and in 1871 again began to rise, but did not soon recede, probably because the "drain" in the Alachua Sink became plugged. What resulted was Alachua Lake, which was declared a navigable lake by the state legislature. A lakeside park was built during the 1880s near Boulware Springs by P.M. Oliver, and it included a zoo featuring birds and a large black bear.

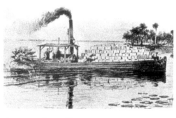

ALACHUA LAKE STEAMER.

This drawing by James Calvert Smith, based on the recollections of J.A. Avera, shows the operation of a paddle steamer across the vast Alachua Lake before its drain became unplugged and it turned into Paynes Prairie south of downtown Gainesville.

Boats began to traverse the large lake, including the steamships and barges of the Alachua Steam Navigation and Canal Company. The thirty-two-foot steamship *Chacala* was operated on Alachua Lake by James Croxton, carrying passengers. The water level began to decrease in 1891, and in 1892 the water suddenly dropped eight feet and left an uncountable number of dead fish to rot in the

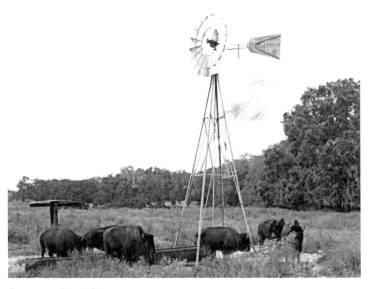

GRAZING ON PAYNES PRAIRIE.

After Alachua Lake drained to form Paynes Prairie, the land was used for grazing cattle. This 1976 photo shows an experimental herd of American bison that was introduced to the area and resulted in beefaloes, a cross between bison and beef cattle.

sun. The *Chacala* was stranded in muck and eventually rotted, leaving only the propeller.

There is still water near the "drain," called the Alachua Sink and Prairie Sink. Some day, if the passage to the subterranean limestone aquifer is ever again closed, the prairie could return to being a lake.

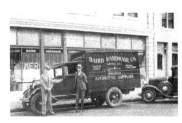

BAIRD HARDWARE.

For ninety-one years, Baird Hardware was a prominent downtown business. This photo from the 1920s shows one of its delivery trucks in front of its store at the corner of University Avenue and SE 1st Street.

BAIRD HARDWARE COMPANY

In 1881, Eberle and Emmett J. Baird moved to Florida and started the E. Baird & Bros. Saw and Planing Mill in Hague. They produced longleaf yellow pine lumber, crates, laths and shingles. In 1890, Eberle sold his interest in the business and moved to nearby Gainesville. Not long afterward, Emmett also moved there and ran a crate and vegetable basket factory.

In 1890, Eberle Baird founded Baird Hardware, which continued in business until 1981. It opened in the second building from the north end of Courthouse Square,

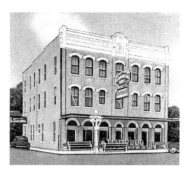

COMMERCIAL HOTEL.

The Alachua Hotel was built on S. Main Street in 1885, with railroad tracks just a few feet from its front door. It was renamed White's Hotel, the Seminole Hotel, the Imperial Hotel and the Commercial Hotel, which was its name when this photo was taken during the 1940s.

and on May 23, 1924, Eberle purchased larger quarters next door to the north at the corner of E. University Avenue and SE 1st Street, eventually taking up three-quarters of a city block. By 1900, it was Florida's largest hardware store, and its stock included mining equipment, blinds and knives.

Cicero Addison Pound Sr. started working for the company when he was a teenager. On April 1, 1930, upon the death of Eberle Baird, Pound took over as its president. Pound had a strong interest in outdoor activities and sports, including boat racing, and this was reflected in the company's large inventory of sports equipment. The store sold boats and gave demonstrations of boats and motors on Newnan's Lake and elsewhere. From the mid-1920s until 1936, Baird's was the state's exclusive distributor for the Johnson Outboard Motor Company.

Baird's had a large scale in the rear of the store, and everyone was invited to come in and see how much they weighed. Many did, and while passing through the store they passed displays of electric fans, scooters, wagons, household appliances, sports equipment and traditional hardware items. Often this trip motivated them to purchase items they hadn't previously realized they needed.

The company began liquidating its inventory in May of 1980 and dissolved on January 31, 1981. Its warehouse property was donated to the University of Florida. In September of 1981 the warehouse was sold to Akira and Associates, Limited, and was later renovated for other uses.

PORTER'S QUARTERS

In 1894, the area bounded by Depot Avenue, SW 4th Avenue, S. Main Street and SW 6th Street was developed as residences for black servants and laborers. It was likely named for Dr. Watson Porter, a former Union army surgeon, the white principal of the Union Academy and Gainesville's mayor in 1873. Dr. Porter purchased land in the southwest part of the city. He and his wife, Olivia A. Porter, sold it to black individuals and encouraged them to develop self-sufficiency as farmers.

BUSINESS DISTRICT.

As Gainesville grew, businesses opened along the south side of Courthouse Square to complement those on the other three sides. This photo from the 1890s shows some of the stores along Union Street, now known as SE 1st Avenue.

After a period of deterioration, in the late 1980s efforts were made to improve the condition of these residences. The park at Tumblin' Creek was renovated and the Porter's Oaks housing project improved the residential area. Grandmother's Park was created to provide a safe playground. Homes were built for those who could not qualify for credit under normal requirements. Porter's Community Center opened to provide a place for children to play while they weren't in school.

THE BIG FREEZE

On December 26, 1894, a freeze damaged Florida's citrus groves just three days after eighty-degree temperatures were reported. Near Gainesville, the temperature dropped to near fourteen degrees. The freeze lasted for thirty-six hours, but some of the citrus trees began to recover during a warm and wet January that promoted new shoots. However, a second freeze hit on February 7, 1895, and lasted for three days, practically wiping out the trees. The eleven-degree temperature caused a freeze so intense that the sap froze inside the trunks, many of which split open, sounding like gunshots, and crashed to the ground. As a result of the devastation of the major crop, many growers left the area. Small settlements turned into ghost towns and larger ones suffered a decline in population. Those who remained sometimes turned from citrus to vegetables, lumber or other activities.

Some growers replanted their groves and about the time they were mature enough to begin producing fruit, another freeze hit on February 9, 1899. A temperature of six degrees was low enough to ruin all the groves, and the area's citrus industry was wiped out, never to return to any substantially productive level.

BOULWARE SPRINGS

With the failure of the water well project on Courthouse Square, the city looked for another source of water for its citizens, both for personal needs and for dousing fires. The city acquired Boulware Springs near Paynes Prairie for $2,500. It was claimed that the water

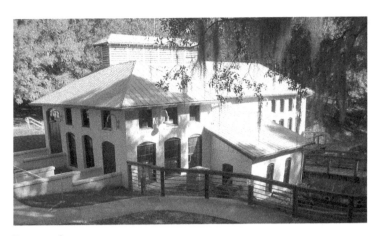

BOULWARE SPRINGS.

Shown in this recent photo is the pump house constructed in 1891 to provide water to the city from Boulware Springs. It was the primary or secondary source of city water until 1977, and now is a site to visit at a popular city park. *Photo by the author.*

from Boulware Springs "was second to none in the South and inferior only to the Poland Springs water of Maine."

Gainesville's first waterworks were constructed there with an 1891 pumping station that could provide 300,000 gallons of potable water each day. The availability of water through mains installed in the city helped to convince the state to locate the University of Florida in Gainesville. Initially, the university was provided its water for free.

F.W. Cole, James W. Graham and H.E. Taylor formed the Gainesville Electric & Gas Company in 1887, and received a city franchise to provide electric and gas power. Gas was distributed to homes and the company agreed to furnish two electric lights on Courthouse Square and keep the city clock illuminated until midnight. Growth of the city, especially with the arrival of the University of Florida in 1906, strained the company to capacity and the quality of service deteriorated. In 1911, the city refused to pay a disputed bill of $7.30, the company turned off the lights and the city cancelled the franchise.

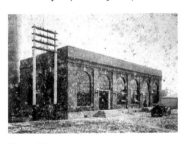

POWER PLANT.

Gainesville was provided electric power by a private franchisee from 1887 until 1911, when the city took over. This photo was taken not long after the new municipal power plant opened in 1914.

A lawsuit brought by Gainesville resulted in the company being required to sell the power plant to the city. As the Gainesville Regional Utilities Plant, it replaced the Boulware Springs waterworks in 1914, with Boulware Springs water supplementing the new facility's production until 1977. In 1990, the 110 acres including

Boulware Springs were made into a city park with trails and the western terminus of the paved Gainesville-Hawthorne State Trail.

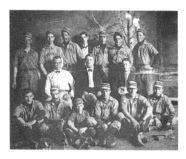

OAK HALLS.

Gainesville's minor league baseball team, named for the home of Tillman Ingram located near the baseball diamond, provided a major source of entertainment starting in the 1880s. Shown here is a team picture from 1903.

BASEBALL

Beginning in the 1880s, baseball teams formed in many towns across the country, including Gainesville. Visiting professional teams often played exhibition games in small towns, and Florida had attractive opportunities for spring training while Northern baseball diamonds were unavailable because of inclement weather.

The local team was known as the Oak Halls and they provided the main focus on local sports during the 1890s, prior to the arrival of the University of Florida. They played on a field near the present-day Hippodrome State Theater when the structure on that site was known as Oak Hall.

In 1919, the city attracted the New York Giants for their spring training, in part by completing for their use what later became known as the Women's Gymnasium on the university campus. When the Giants arrived, they were met by the university marching band and a parade, and the mayor presented them with the key to the city.

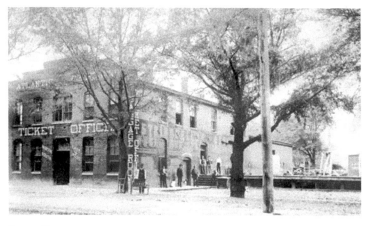

TICKET OFFICE.

In addition to automobiles and horse-drawn vehicles, Main Street traffic included trains. This photo of 104 N. Main Street taken in about 1900 shows the Atlantic Coast Line Railway ticket office, removed by 1954 to make room for the new First National Bank.

THE 1900s

KIRBY SMITH SCHOOL

In 1900, the Gainesville Graded and High School was built for $30,000 at 620 E. University Avenue. It had twelve classrooms, a large auditorium and an office for the principal. In 1905 or 1906, a high school program was added and the school was expanded in 1912 by the addition of a second building of fifteen rooms with modern toilets and steam heat.

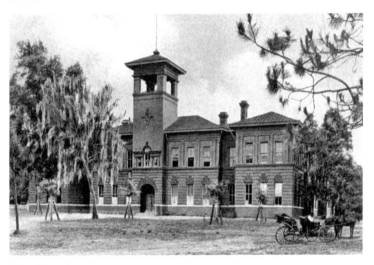

KIRBY SMITH SCHOOL.

This building was named for a Confederate general who led the last contingent of soldiers to surrender, more than six weeks after Robert E. Lee did at Appomattox Court House. After seventy-seven years as a traditional school, it was converted to an adult education center.

LIBRARY

In 1903, the Twentieth Century Club was formed as a literary society by local women who donated books to establish a library for the use

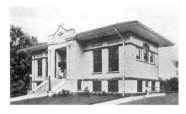

First Library.

Gainesville needed a building to house the collection of books begun in 1903 by the women of the Twentieth Century Club. This 1918 design was typical of libraries in Florida and elsewhere that were built with the financial assistance of the Carnegie Library Association.

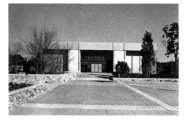

Old Library.

This 1968 structure was too small from its beginning, but served as the main library until 1991. Now known as the "Old Library," it functions as an annex for the city hall located next door to the west.

of its members. Just prior to World War I, the club held a drive to raise $10,000 to construct a new free public library, which voters approved in 1915 to be supported by taxes. The Carnegie Library Association provided additional financial help to construct a new library, which opened in 1918 at 419 E. University Avenue.

In 1956, a new six-thousand-square-foot library opened near Sweetwater Branch and two years later, it offered service to all residents of Alachua County. Branches opened in High Springs, Hawthorne and Micanopy in 1959 and the library soon obtained its first bookmobile.

The new library opened at 222 E. University Avenue in 1968, with the children's room furnished by a $2,500 donation from the Junior Women's Club of Gainesville. Today's modern library building at 401 E. University Avenue was completed in 1991, supplemented in later years by branches in Newberry, Waldo, Archer and in Gainesville on Tower Road and in the Millhopper area.

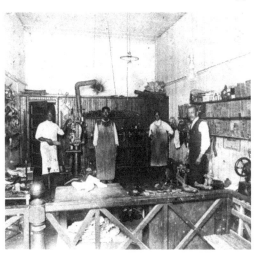

Duval Shoe Hospital.

This shoe repair shop near the courthouse was owned and operated by Charles W. Duval, a prominent black citizen of Gainesville. He donated five acres for the construction of an elementary school, which was named for him in 1937.

FOOTBALL

Although 2006 was celebrated as the one hundredth anniversary of the beginning of University of Florida football, its actual beginning is traced to 1889 at the Florida Agricultural College in Lake City. As long as the university considers its predecessor institutions to carry its date of founding back to 1853, the activities of those institutions should also be considered with respect to other anniversaries.

In 1889, intercollegiate football was recognized at the Florida Agricultural College. A team was formed and an engineering professor volunteered to coach it, assisted by chemistry professors and the pastor of the Lake City Presbyterian Church. That year, they were challenged to a game by Stetson University, but it wasn't until 1901 that the game actually took place. The first game was played in Jacksonville on November 22, 1901, and Stetson beat the Florida Agricultural College by a score of 6–0. They played a rematch the following year, and Stetson won with a score of 6–5, under rules that then allowed a five-point score.

In 1906, after the school had been renamed as the University of Florida and moved to Gainesville, six games were scheduled. The university shut out Rollins College (6–0) and the Riverside Athletic Club of Jacksonville (19–0) before losing to Savannah by a score of 27–2. Dissention on the team resulted in its disbanding and the cancellation of its remaining games for that season.

STUDENT NEWSPAPER

A student-owned independent newspaper named the *University Times* was established to serve the university upon its arrival in Gainesville. When it became a publication of the university administration in 1912, it was renamed the *Florida Alligator*. It was governed by the Faculty Committee on Student Publications until the 1930s, when it was placed under the control of a committee of students and faculty. Called the Board of Student Publications, it oversaw the newspaper, the yearbook (the *Seminole*), the *Florida Magazine*, general interest magazines and the university's literary publication (the *Florida Quarterly*).

The *Florida Alligator* was printed by the *Gainesville Daily Sun* until 1963, when the student weekly became a daily newspaper and moved to the printing plant of the *Leesburg Commercial*. The move also switched it from being printed with hot lead composition on a letterpress to an offset process. Later, it was printed at the office of the *Ocala Star-Banner*. It utilized other out-of-town printers until it was brought back to the *Gainesville Sun* after it also had switched to the offset printing process.

The offices of the newspaper were located in the basement of the old Florida Student Union in what was renamed Dauer Hall, then

in 1968 moved to the third floor of the J. Wayne Reitz Union. In 1973, the newspaper became the *Independent Florida Alligator*, no longer officially affiliated with or overseen by the university, and moved to offices on University Avenue across from the campus.

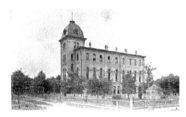

FLORIDA AGRICULTURAL COLLEGE.

This photo from about 1897 shows Lecture Hall, built between 1884 and 1888. It and other buildings in Lake City composed the campus of the Florida Agricultural College, renamed the University of Florida in 1903 and relocated to Gainesville in 1906.

UNIVERSITY OF FLORIDA

The Florida Agricultural College was originally supposed to be located in Gainesville, then its proposed location was changed to Eau Gallie, but it never opened there, either. Instead, it opened in Lake City in 1884. It was renamed the University of Florida in 1903. The first three fraternities at the university appeared in 1904. Alpha Tau Omega, which had formed in Tallahassee in 1884, then transferred to Lake City and had its charter withdrawn in 1890, was reactivated on June 15. Kappa Alpha formed on October 4 and Pi Kappa Alpha was added on November 19.

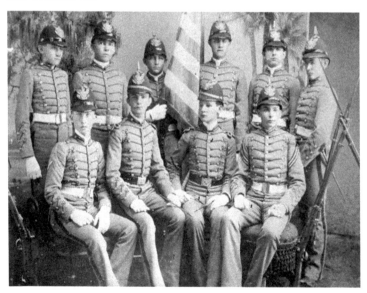

UNIVERSITY OF FLORIDA CADETS.

This group portrait shows how the male students at the University of Florida looked about the time of their move from Lake City to Gainesville. In addition to being an academic institution, there was also a strong military influence.

BUCKMAN HALL.

BRYAN HALL.

This is one of the first Collegiate Gothic buildings on campus, designed by architect William Edwards and built in 1907. It was the home of the University of Florida College of Law from 1914 until 1969.

Built in 1906–07, this building was designed to include dormitory rooms, classrooms, a mess hall, laboratories, a machinery hall and an assembly room. After a century, it still serves as a dormitory.

In 1904, Andrew Sledd became the president of the University of Florida while the campus was located in Lake City. He encouraged the state to consolidate its schools, a movement backed by Governor Napoleon Broward. What resulted in 1905 with the passage of the Buckman Act was one school for white males (University of the State of Florida, officially shortened to University of Florida in 1909), one for white females (the Florida Female College, now Florida State University), one for black students (Florida Normal and Industrial College for Negroes) and one for the deaf and blind (Blind, Deaf and Dumb Institute). Sledd was chosen to be the president for the new Gainesville campus. The town's chances for selection were helped greatly by its offer of money, land and free water. Soon, it consolidated with several other institutions, including the South Florida Military College in Bartow, Gainesville's East Florida Seminary and the St. Petersburg Normal and Industrial School.

Architects were invited in 1905 to submit designs for the campus and initial college buildings. One such design was prepared by noted architect Henry John Klutho, but his was rejected in favor of the Collegiate Gothic style of William A. Edwards. His firm of Edwards and Walter designed most of the early buildings.

In 1906, most of the instructors at the Lake City campus moved to Gainesville to teach the consolidated university's 102 students. President Sledd continued as head of the university until he lost his political support when Albert Gilchrist became governor in 1909. Sledd was replaced by Albert A. Murphree, who immediately reorganized the school into the four colleges of agriculture, arts and sciences, engineering and law. Later in 1909, the graduate school was established.

THE 1910s

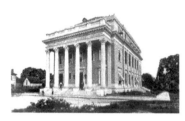

FEDERAL BUILDING.

This photo was taken shortly after the January 1911 completion of the imposing building south of Courthouse Square, which for fifty-three years served as the main Gainesville post office. It also served as the U.S. Land Office and is now a theater.

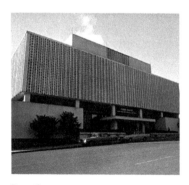

POST OFFICE.

In 1965, this modern building was completed to serve as the main Gainesville post office and the federal courthouse. It is located a few blocks to the east of the old one, closer to Sweetwater Branch. This photo was taken in 1971.

FEDERAL BUILDING

Planner and builder Tillman Ingram had a home named Oak Hall, plus an extensive plantation in Hogtown to the northwest of Gainesville. Oak Hall was later used as a public building, including the hospital of the Atlantic Coast Line Railway and the U.S. Land Office. In 1903, the federal government acquired it and moved it to 310 SW 1st Street to make room for a new federal building. Oak Hall later became the headquarters of the local chapter of Woodmen of the World.

Architects Thomas Ryerson and James Knox Taylor designed a yellow brick structure on a granite foundation, begun in 1909 and completed at 25 SE 2nd Place in January of 1911. Its style is Beaux-Arts Classical with some innovations that were quite modern for its time, including an elevator and steam heat. The exterior features a monumental portico with six Corinthian columns supported by granite blocks, carved limestone and granite details. The roof is clay tile, beneath which is intricate scrollwork.

The post office occupied the first floor, the courthouse was on the second and the U.S. Land Office was on the third floor with other offices. The original doors were covered with leather.

The post office moved from the building in 1964 when its new facility was completed on SE 1st Avenue. The federal building was placed on the National Register in 1978 and was converted to the Hippodrome State Theater in 1980 under the supervision of architect Al Dompe.

CHESTNUT FUNERAL HOME.

This is the present office of the Chestnut Funeral Home, founded in 1914 to handle burials of black residents of the area. The company remains one of Gainesville's oldest, run by the descendants of one of its founders, Charles Chestnut Sr. *Photo by the author.*

CHESTNUT FUNERAL HOME

One of Gainesville's oldest businesses is the Chestnut Funeral Home, founded in 1914 by Matthew E. Hughes and Charles Chestnut Sr. as the Hughes and Chestnut Funeral Home. Charles, born in 1886, was a third-generation resident of Alachua County and has been called the "Grandfather of Black Funeral Service." The business continues today under the direction of his descendants. Lincoln High School named its auditorium after Charles Chestnut Sr. to honor him for his community leadership.

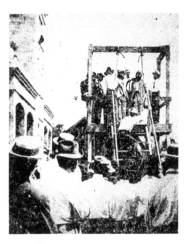

PUBLIC JUSTICE.

With the presence of the university and other schools, Gainesville was a modern, enlightened town. However, it retained quite a bit of its early frontier roots. Shown here is the public hanging of convicts Cain and Fortian Perry, which took place in 1914 or 1915.

GAINESVILLE SUN

In 1917, the newspaper was sold by Henry Hamilton McCreary, who had begun publishing it during the late 1880s. It was acquired by the Pepper Printing Company, which moved it from the Porter-Haymans-Woodbridge Building in 1926 to 101 SE 2nd Place.

FLORIDA STATE MUSEUM.

Shown here is a small portion of the museum's large collection of Indian artifacts. The photo was taken during the 1950s, at a time when the museum's holdings were split between the Seagle Building downtown and the basement of Flint Hall on campus.

FLORIDA MUSEUM OF NATURAL HISTORY.

One of the most popular exhibits in the museum is the replica of a Florida cave. Visitors walk among rock formations that are very similar to those found underground naturally at the Florida Caverns State Park in Marianna.

FLORIDA MUSEUM OF NATURAL HISTORY

In 1891, Frank Pickel was a natural science professor at the Florida Agricultural College in Lake City who purchased research collections of fossils, minerals and human anatomy models to use in his teaching. Other professors added to the collection, which was brought to Gainesville when the school moved in 1906. For a time, they were displayed in Thomas Hall, then were moved to the basement of Flint Hall. In 1914, Thompson H. Van Hyning was appointed museum director and served in that capacity for twenty-nine years. The state legislature officially recognized the museum in 1917, naming it the Florida State Museum.

In 1937, the museum had outgrown its facility on campus and moved many of its artifacts to the Seagle Building close to downtown. Others remained in Flint Hall, available to faculty and students within the Department of Biology. These final artifacts were also moved to the Seagle Building in the mid-1960s. Joshua C. Dickinson Jr., who had become the museum's director in 1961, pushed for a new building.

During 1968, the National Science Foundation granted $1.1 million, to be matched by other funds, for construction of a museum building on campus. Construction was completed in 1970 as Dickinson Hall, to house the research collections, public exhibits and education programs.

The name of the museum was changed to the Florida Museum of Natural History in 1988.

During 1995, construction began on Powell Hall on Hull Road near SW 34th Street, named for benefactors Bob, Ann, Steve and Carol Powell of Fort Lauderdale. The 55,000-square-foot Education and Exhibition Center opened in 1998. It and the Samuel P. Harn Museum of Art and the Curtis M. Phillips Center for the Performing Arts compose the Cultural Plaza.

UNIVERSITY OF FLORIDA

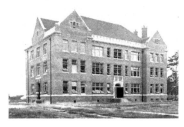

NEWELL HALL.

Agriculture has always been a major area of emphasis for the University of Florida. This 1910 photo shows one of the earliest buildings on campus, the Agricultural Experiment Station, renamed Newell Hall in 1944.

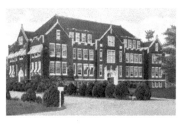

ANDERSON HALL.

When built in 1913, this was a general purpose building known as Language Hall. It was later renamed Anderson Hall to honor one of the university's professors of Latin and Greek, who also served as the first head of the Graduate School.

The 1910s opened and closed with Albert A. Murphree as the university president. Prior to coming to the University of Florida, Murphree was a mathematics instructor and the president of the West Florida Seminary during the period of its conversion to the Florida State College (now known as Florida State University). He moved to Gainesville to fill the void caused by the pressured resignation of Andrew Sledd.

In 1910, orange and blue were chosen as the school's colors, borrowing from the blue and white it had at the Lake City campus and the orange and black of the East Florida Seminary in Gainesville. Its mascot, the gator, was chosen in 1911, perhaps borrowing the nickname of the football team's captain, Neal "Bo Gator" Storter. In 1912, a teachers' college and normal school were formed and the student newspaper began publication under the name of the *Florida Alligator*.

When the United States entered World War I, the university band enlisted as a unit and became the 124th Infantry Band. More than four hundred students and alumni served in the war. A battalion of four hundred trained on campus.

THE 1920S

DUCK POND

Major William Reuben Thomas developed a portion of the northeast section of town as Sunkist, near his home, which was named Sunkist Villa. In 1922, others endeavored to continue developing that area, calling it the Highlands. It featured a park one hundred feet wide straddling Sweetwater Branch, a stream that meandered through what had been Thomas's pasture.

In 1926, a section of Sweetwater Branch was converted into a water retention area called Vidal's Lake (named after the city engineer who supervised the project), now commonly referred to as the Duck Pond area. It was one of the city's first planned public green spaces, and is still a popular place to stroll and relax. The Duck Pond and the surrounding neighborhood make up the Northeast Historic District, added to the National Register in 1980.

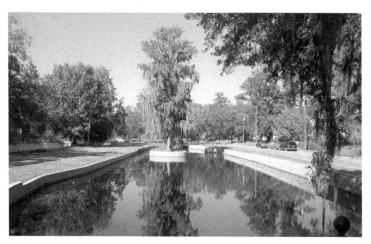

DUCK POND.

Although today it is often difficult to find any ducks or other waterfowl in the Duck Pond, the park bordered by large attractive homes remains a pleasant place to walk or relax, just a few blocks from heavy downtown activity. *Photo by the author.*

HOTEL THOMAS.

This is an aerial view of the Thomas property from the late 1920s, following the completion of the hotel portion that was added to the home of William Reuben Thomas. It is now called the Thomas Center, a popular venue for social activities.

HOTEL THOMAS

Construction began on Sunkist Villa in 1906. It was started by Charles W. Chase, the manager of the Dutton Phosphate Company, but he died in 1909 before it was complete. The property was purchased by William Reuben Thomas and he had the home completed in 1910. The estate was known as the showplace of Gainesville, and after a time he started operating it as a hotel. Near the main house were a gardener's cottage, dairy barn and a gymnasium. Some of the land was sold by Thomas in 1922 for the development of the Highlands (Duck Pond) neighborhood.

In 1926–28, the additional hotel portion on the north end was built, utilizing the design of William A. Edwards, who had served as the university architect for the previous twenty years. On the hotel grounds was constructed a miniature golf course. The residence portion to the south of the main hotel was converted to a restaurant, which served meals until 1968.

The ninety-four-room hotel exhibits a French Classical style with some Mediterranean elements such as a stuccoed exterior, festoons over the doorways, arches and a red clay tile roof. There are two lounges, a turtle fountain, multiple fireplaces and an indoor courtyard.

The complex served for a short time as a campus of Santa Fe Community College while its own campus was being constructed northwest of Gainesville. In 1972, Historic Gainesville, Inc., was formed to preserve the hotel, which the following year was added to the National Register. The hotel was acquired by the city in April of 1974 and restored in 1976–78 as city offices and a cultural center. Now known as the Thomas Center, it is a popular setting for weddings, large meetings and other events.

NEWNAN'S LAKE

East of Gainesville, Newnan's Lake has been a popular outdoor destination from the early days of settlement. It was easily reached by what is now Hawthorne Road (State Road 20) and provided a place to swim and go boating. It still is popular for bass fishing. It is shaped like a kidney and covers about 7,400 acres.

When the area was populated with Indians, the lake was called Pithlachoco. White settlers renamed it after Colonel Daniel Newnan,

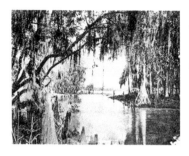

NEWNAN'S LAKE.
This large picturesque lake east of Gainesville has long been a popular recreation spot, as it was when this photo was taken in 1906. It has also been the source of major archaeological finds, many of which can be viewed in the Florida Museum of Natural History.

a member of the Georgia militia during the War of 1812, the same individual after whom Newnansville was named.

In 2000–02, during a period when the water level was abnormally low, more than one hundred Indian dugout canoes were found along the lake's northern shore, preserved by being buried in muck. They were dated to between five hundred and five thousand years old. The archaeological find practically doubled the number of canoes ever found in the state and was the largest such single find anywhere in North America.

KELLEY HOTEL.

W. McKee Kelley intended to have the tallest building in Gainesville be a hotel named after him. Construction began in the mid-1920s, Kelley ran out of money and the tower stood, uncompleted, for about a decade.

KELLEY HOTEL

F. Lloyd Preacher and Rudolph Weaver designed a building with a Mediterranean Revival style to be the Kelley Hotel for W. McKee Kelley, a St. Petersburg real estate developer who came to Gainesville in 1925 and acquired several parcels of real estate costing $1,250,000. Construction began in 1926 on a ten-story building projected to cost $600,000, with half of the capital planned to be contributed by Kelley and half by local investors. If all had gone according to plan, the luxury hotel would have opened for business on January 1, 1927.

By the end of 1926, the superstructure of the building, also known as the Dixie Hotel, was more than nine stories tall. However, Kelley ran out of money and his failure to continue contributing to the project absolved the local bond subscribers from having their money used. Construction was halted and no local investor lost money on the project.

The building was saved by the Works Progress Administration and Georgia Seagle, who contributed $20,000 toward its completion,

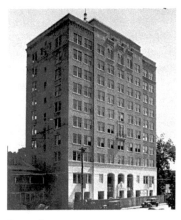

SEAGLE BUILDING.

With contributions from Alachua County, the City of Gainesville and Georgia Seagle, the hotel project was redesigned and completed. This is how it looked when it opened in 1937, just before it became the property of the state.

supplemented by $10,000 from the city and $10,000 from the county. The structure was redesigned by the university's School of Architecture and it finally opened in 1937. The building was donated to the state and, from 1937 until 1979, was used by the University of Florida as offices and the Florida State Museum.

During the 1940s, the building was named the John F. Seagle Building for the brother of benefactor Georgia Seagle and was considered to be the tallest in the Southeast. During 1982–83, it was converted to luxury condominiums, the Heritage Club and retail and office space.

DIXIE HIGHWAY

Carl Fisher of Indianapolis, who had made his fortune in the new auto industry, conceived and promoted the idea of a highway from Chicago to Miami. The Dixie Highway Association was created and

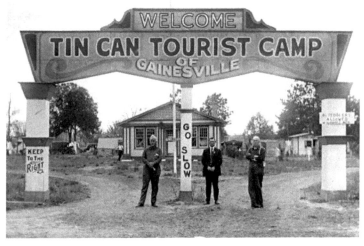

TIN CAN TOURISTS.

The Dixie Highway brought many visitors to Florida from the Midwest. They were called tin can tourists because of what they lived in and what they ate their food from. Gainesville's main tourist camp was located on the later site of Alachua General Hospital.

a route was established, including both a coastal and inland route through Florida. In 1915, Fisher led an auto cavalcade from the Midwest to Miami, popularizing auto trips to Florida. The Dixie Highway was officially opened in 1925, stretching from the Canadian border at the northern tip of Michigan to Miami. For much of its route, including that through portions of Florida, it follows the route of the former Black Bear Trail. The inland route generally followed the present U.S. 441.

By 1926, the Dixie Highway was paved from Lake City all the way to south Florida, except for the two-mile stretch just south of Gainesville, passing through Paynes Prairie. A 1925 flood had raised the water level several feet, bringing back a temporary lake. By the spring of 1926 the water level had subsided and traffic was allowed to proceed on the unpaved fill that was laid in anticipation of pavement. At the north and south ends of the prairie were road entrances open for five minutes at a time, every fifteen minutes. These entrances allowed cars to head north to south on the single lane and exit the road before other cars would be allowed to head south to north. The road was completed in 1927, so traffic in both directions could use it simultaneously.

FLORIDA FARM COLONY

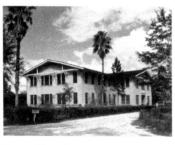

FLORIDA FARM COLONY.

This is one of the office buildings at the Florida Farm Colony, which opened in 1921 to isolate mentally deficient individuals from the rest of the population. The institution remains today as Tacachale, with emphasis on education and employment.

A commission was appointed in 1915 to study "the needs of the retarded person," and on the basis of its findings the state legislature enacted a law in 1919 that established the Florida Farm Colony for the Feeble-Minded and Epileptic. Its directives were to provide: an asylum for the care and protection of feeble-minded and epileptic individuals; a school for their education and training; and a colony for their segregation and employment so that they would be prevented from reproducing their kind, and to relieve the communities and state from the heavy economic and moral losses arising by reason of their existence.

The institution opened in November of 1921 on the outskirts of Gainesville, making it the state's oldest and largest community for the developmentally disabled. It initially had three buildings located on three thousand acres, and a population of 240. It was renamed in 1957 as the Sunland Training Center, the same name as four other similar institutions located throughout the state.

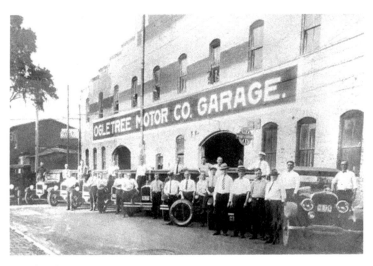

TEST CAR FLEET.

Gainesville was a regular stop for fleets testing cars and tires, including this 1927 one from the B.F. Goodrich Company. They are posed in front of the Ogletree Motor Company, which sold Overland and Willis Knight autos.

There were over two thousand people being served by the center in 1957, a number that has been reduced to a little over five hundred. The facility on Waldo Road was recently renamed Tacachale from a Timucuan word meaning "to light a new fire," representing a new beginning and hope for the future. The land has been reduced to eight hundred acres with a total of 155 buildings.

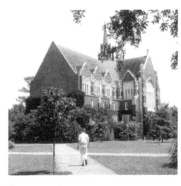

UNIVERSITY AUDITORIUM.

The magnificent University Auditorium was begun in 1922 and included a chapel and large pipe organ. It was used for concerts and assemblies even though the north façade was incomplete when construction was halted in 1925. It was finally finished in 1977.

UNIVERSITY OF FLORIDA

In 1924, the School of Pharmacy was founded, followed the next year by the School of Architecture. In 1927 came the College of Commerce and Journalism. The first part of the library was completed in 1925. That same year saw the enrollment of the first female student (other than those allowed during the summer term for teachers), Lassie Goodbread-Black. In 1926, the campus landscaping plan was developed by the Olmsted Brothers, the same landscape architects who planned Central Park in New York City.

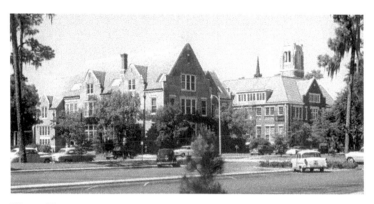

WALKER HALL.

Walker Hall opened as the Mechanical Engineering Building in 1927. It is shown here in a 1957 photo next to Benton Hall, a College of Engineering building that stood from 1911 until 1969, when it was replaced by Grinter Hall.

In 1927, President Albert Murphree died, leaving as part of his legacy the forty-six buildings erected during his tenure at the university. More importantly, under his leadership the university took on an organizational structure that is in large part still in effect today. Murphree was succeeded by Vice President James Farr, who had been in charge of the English department in Lake City in 1901 and later in Gainesville. He began serving as the university's first vice-president in 1905.

The next president was John J. Tigert, who had taught philosophy in St. Louis and served as the president of Kentucky Wesleyan College. He then chaired the departments of philosophy and psychology at the University of Kentucky and coached the football team. After serving as a member of the American Expeditionary Force during World War I and as commissioner of education under U.S. Presidents Harding and Coolidge, he was appointed as president of the University of Florida in 1928, when the student enrollment was over two thousand.

Also in 1928, the campus radio station, WRUF, began broadcasting. Major Garland Powell was appointed its director and its first office was in an English Tudor–style building now occupied by the university's police department. WRUF became a commercial station during the 1930s.

With the onset of the Great Depression, Tigert's early years saw little growth in the number of campus buildings. Instead, emphasis was placed on the reorganization of the undergraduate program and curriculum reform.

THE 1930s

TUNG OIL

During this decade, the tung oil industry in Alachua County boomed: 90 percent of the tung oil manufactured in the United States came from the county, and what became the area's largest crop was celebrated with parades and festivals. Tung oil is made from nuts and was an important component of paint. Freezes and synthetic products developed during World War II lessened the need for tung oil and reduced its importance to the local economy.

TUNG OIL FESTIVAL.

This photo features several participants on a parade float during one of Gainesville's tung oil festivals of the 1930s. Such festivities became less popular during the next decade because of the focus on World War II and the development of replacement solvents.

UNIVERSITY OF FLORIDA

Under President Tigert, the School of Forestry was created, as was the General College in 1935. The existence of the General College allowed the other colleges to shift their emphasis from the basics to

DAIRY PRODUCTS LABORATORY.

This 1937 photo shows the Dairy Products Laboratory building as it was completed, including cold storage rooms, offices, classrooms and laboratories. It was later renamed the Dairy Science Building.

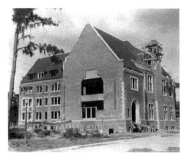

DAUER HALL.

When it opened in 1937, this building served as the student union with a bookstore, visitors' hotel rooms, a soda fountain and other amenities every student needed. It was superceded by another union in 1967 and was converted to classrooms and offices.

more upper-level courses. In 1930, the Institute of Inter-American Affairs (the predecessor of today's Center for Latin American Studies) was created, as was the Bureau of Economic and Business Research. In 1939, the Research Council was created to stimulate research and develop policies on copyrights and patents. The ROTC presence on campus was expanded.

In 1930, the first football game was played at the nearly 22,000-seat Florida Field, which was dedicated to alumni who died during World War I.

THE 1940S

AIRPORT

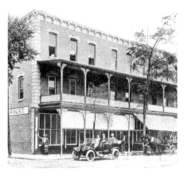

BROWN HOUSE.

A fixture along N. Main Street for the past century has been the three-story brick building known as the Brown House and, by the 1940s, the Gilbert Hotel. Today it is an office building resembling this 1910s photo, but with the removal of the veranda.

The city acquired 150 acres to the northeast to build an airport. It was expanded and improved by the WPA in 1941, in anticipation of World War II. The field was known as the Alachua Army Airfield for the use of the Army Air Corps and the Army Air Force. On March 2, 1942, it was officially named the John R. Alison Airport, after a University of Florida alumnus who served with valor and distinction in World War II. He was an observer in England, trained Russian flyers and was awarded the Distinguished Flying

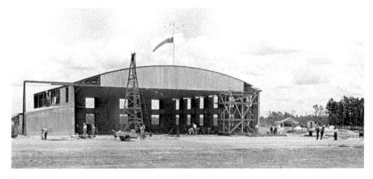

AIRPORT.

This photo was taken in about 1942, the year the city's airport was named for World War II airman John R. Alison and a year after it was expanded and improved by the Works Progress Administration so it would be ready for wartime use.

Cross. After the war, he was appointed as the Assistant Secretary of Commerce for Aeronautics.

In 1948, ownership of the airport returned to the city. Although named for John Alison, it came to be generally known as the Gainesville Municipal Airport until October of 1977, when it was officially renamed as the Gainesville Regional Airport. Two years later, the terminal was dedicated to honor John R. Alison.

UNIVERSITY PRESS OF FLORIDA

In 1945, the University of Florida Press was founded to publish books about Florida. Other universities throughout the state also began establishing publishing houses, and to avoid duplication the State Board of Regents established a system-wide consortium. As a result, in 1973 the University of Florida Press became the University Press of Florida, serving ten state universities.

UNIVERSITY OF FLORIDA

President Tigert served as a member of the National Rules Committee for college sports and helped to rewrite the rules for college football. He was largely responsible for creating football scholarships and helped

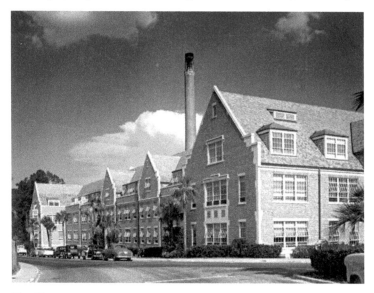

WEIL HALL.

In the late 1940s, this opened as the Engineering Industries Building, used by the College of Engineering led by Dean Joseph Weil from 1937 until 1963. The building was later dedicated and renamed in his honor.

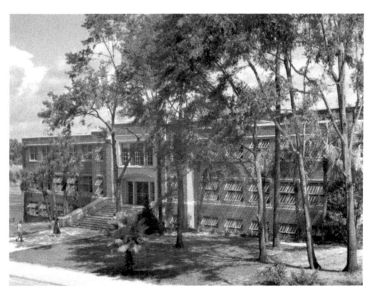

FLORIDA GYMNASIUM.

This facility was dedicated in 1949 and opened on January 18, 1950. Nicknamed "Alligator Alley," the dark and cramped building included the home court of the University of Florida basketball team for three decades.

to form the Southeastern Conference. For his years of dedication to athletics, he was named to the College Football Hall of Fame. Tigert left the university in 1947 and later taught philosophy at the University of Miami.

Tigert was succeeded by Interim President Harold Hume, who had begun teaching botany at the Lake City campus in 1904. While serving as the head of the university, he remained active within the College of Agriculture. Hume continued as its provost when J. Hillis Miller became the president in 1948.

Miller had taught psychology at the College of William and Mary and at Bucknell University, then was president of Keuka College and associate commissioner of education for the State of New York. When Miller became the University of Florida president, he faced the challenge of rapidly rising enrollment due to the GI Bill and the admission of women. Students numbered 587 in 1945, increased to more than 8,000 in 1946 and it was obvious that the university was going to continue its growth.

The university acquired one hundred housing units from the Federal Public Housing Authority, along with others from military bases such as Camp Blanding. In 1948, they were installed on campus for military veterans and their families. Known as Flavet villages (for *Fla. Vete*rans), each had its own mayor and other officials. The communities were served by a volunteer fire department and a cooperative grocery store.

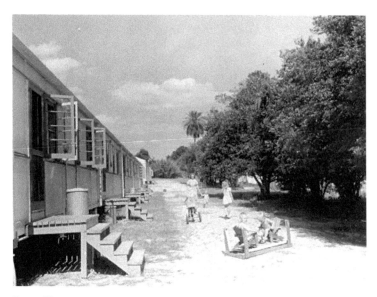

FLAVET VILLAGES.

The postwar influx of veterans seeking higher education brought a housing crisis, which was partially alleviated by barracks set up to accommodate married veterans with children. The last of the "temporary" structures closed in 1974.

VIRGIL HAWKINS.

Virgil Hawkins began his quest for a University of Florida law degree in 1946, but was denied admission because of the color of his skin. A lifelong battle including much litigation finally resulted in his being awarded an honorary degree in 2001, thirteen years after his death.

In 1949, the state legislature approved the establishment of Schools of Medicine and Nursing. Gainesville beat out Jacksonville, Miami and Tampa to be their home. That same year, five black individuals applied for admission to the university, but were rejected and their applications were sent to Florida A&M University. They unsuccessfully attempted to force integration in Gainesville through court petitions.

One of the individuals who attempted to enroll at the University of Florida was Virgil Darnell Hawkins, who had graduated from Edward Waters College in 1930. In the late 1940s, he wanted to enter the UF Law School, and in 1950 the U.S. Supreme Court ruled that he had to be admitted. However, the state had a plan to instead establish a

separate school for black students, something the Supreme Court ruled against in 1956. Florida had to admit black students to its professional schools, but decided to stall as long as possible. Despite another mandate from the Supreme Court, Florida would not admit Hawkins until he could prove he could become a student "without great public mischief."

In the meantime, Virgil Hawkins earned a law degree in Massachusetts, but continued his fight to become a student at the University of Florida. He was granted admission to the Florida Bar but resigned in 1985 when he was brought up on ethics charges, believed by many to be the result of his activities advocating equality. He died in 1988. Six months later, his license was reinstated and the University of Florida granted him its first posthumous honorary degree in June of 2001.

THE 1950s

STREET NAMES

STREET NAMES.

In much of Gainesville, street signs indicating the quadrant and numerical designations have been replaced with new ones such as these, which also show the historical names that were in effect prior to 1950. *Photo by the author.*

At the close of World War II, support increased for the establishment of a quadrant system of street naming. On July 1, 1950, Gainesville eliminated the more picturesque street names that had existed for several decades and, with the exception of University Avenue, Main Street, Waldo Road and Depot Street, went to a grid of numbered streets, avenues, places and so on. Although this made it very easy to find buildings, it also deprived the thoroughfares of their historical connections. In recent years, street signs have begun to show not only the present numbered designations, but also the historical names. A list of the name changes that took place in 1950 is included in the appendix.

MEDICAL CENTER

The university's medical center entered the planning stage in 1950 under architect Jefferson M. Hamilton. A site was chosen on Archer Road because it was accessible on foot from the main part of the campus and by vehicle from off campus, and left plenty of room to expand. The initial medical center buildings were completed in 1956, when its first students began classes. In 1959, it was dedicated as the J. Hillis Miller Health Center to honor the university president who died in 1953, and who had worked during his years at UF to

SHANDS HOSPITAL.

This is a view of the W.A. Shands Teaching Hospital, as it appeared shortly after its opening on October 13, 1959. It is a major part of the J. Hillis Miller Health Center, named for the university president instrumental in obtaining a medical school for the University of Florida.

establish the first medical school in Florida. Its first class graduated in 1960.

The medical center includes several facilities, including the W.A. Shands Teaching Hospital (so named in 1965), the Veterans Administration Hospital (which opened in 1967, connected to Shands Hospital by a tunnel under Archer Road), six colleges, Student Health Services, University Hospital in Jacksonville and the university's Veterinary Medical Teaching Hospital.

GAINESVILLE SHOPPING CENTER

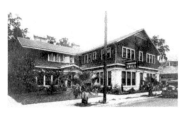

PRIMROSE GRILL.

This building was erected in 1910 and served as the home of a university professor. By the time this photo was taken in the 1920s, it had been converted into temporary lodging and a popular restaurant. In the late 1980s, it became an office building.

The city's first real shopping center opened on NW 6th Street extending north from University Avenue in 1958–59, and was known as the Gainesville Shopping Center. The outdoor strip mall has become much less popular in later years and has difficulty keeping its retail spaces occupied.

UNIVERSITY OF FLORIDA

During the presidency of J. Hillis Miller, the twin focus was on staff development and the construction of campus buildings. A medical college was sought and expanded academic programs were to include ten new fields in which one could earn a doctorate degree.

J. WAYNE REITZ.

This is a portrait of Julius Wayne Reitz, who served as the president of the University of Florida from 1955 until 1967. He led the school during a period of rapid growth, including the addition of hundreds of buildings and thousands of students.

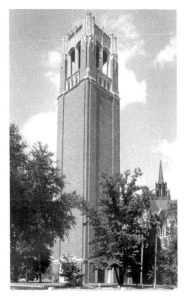

CENTURY TOWER.

This brick landmark was started during 1953, one century after the beginning of state financial support, considered to be the beginning of the University of Florida. Since 1955, it has provided carillon music for the campus.

In 1953, Century Tower was begun as part of the university's centennial celebration, to serve as a monument to students and alumni killed in World Wars I and II. To make room for the tower, it was necessary to remove thirteen holly trees that had been planted in a "W" shape in 1932 to honor George Washington.

Near the end of 1953, President Miller died and was succeeded by Vice President John Allen. The year 1953 also marked the first appearance by the University of Florida football team in a bowl game. The Gators beat Tulsa 14–13 in the Gator Bowl. In 1958, they began a continuing rivalry by playing Florida State University.

Allen, an astronomy professor, served as the director of the Division of Higher Education of the New York State Department of Education before his appointment to the vice-presidency of UF. He was succeeded by J. Wayne Reitz, who took over as the university president in 1955. The person actually selected for the position was Philip G. Davidson, president of the University of Louisville, but he withdrew from consideration when faced with resistance from Florida's acting governor. Reitz was then selected, after having served at UF as the provost for agriculture.

Reitz oversaw an expansion of the university with the construction of over three hundred buildings. The student population grew to eighteen thousand despite the raising of admission standards. Reitz supported dress codes, a faculty disciplinary committee

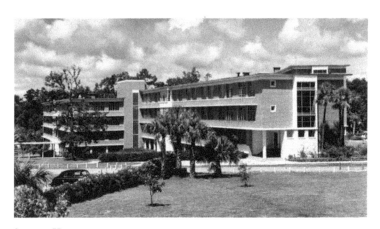

STUDENT HOUSING.

The rapid growth of the student body required construction of several new residence halls to accommodate it. Shown here are two that opened in 1950, North Hall and South Hall. The latter was rededicated as Riker Hall in 2000.

and strict behavior guidelines. He stood up to state governors who attempted to control the operation of the university.

The University of Florida was the first state university to integrate, and it was accomplished with fewer problems than at most other Florida institutions. In 1958, George H. Starke Jr. became the first black student admitted to the College of Law and the entire university, following a federal judge's ruling that black students were eligible for admission to graduate-level professional schools. The court order was granted in exchange for Virgil Hawkins's withdrawal of his application for admission. Although he could not become a student at the University of Florida, Hawkins's efforts resulted in the acceptance of other minority applicants.

THE 1960S

GAINESVILLE SUN

In 1962, the newspaper was acquired by Cowles Magazines and Broadcasting, Inc. During this decade its writers won Pulitzer Prizes for editorials in favor of a minimum housing code and tolerance in school desegregation. In March of 1984, the newspaper moved to a larger facility at 2700 SW 13th Street. It donated its old location at 101 SW 2nd Place to the city.

GAINESVILLE MALL

This shopping center with Morrison's Cafeteria and Maas Brothers Department Store opened on NW 13th Street in 1968. At the time, it was the largest shopping center in north central Florida.

GAINESVILLE MALL.

This 1971 aerial view of the Gainesville Mall on NW 13th Street shows the popular place to shop for everything for nearly a decade. After the 1978 opening of the much larger Oaks Mall on W. University Avenue, this one declined rapidly.

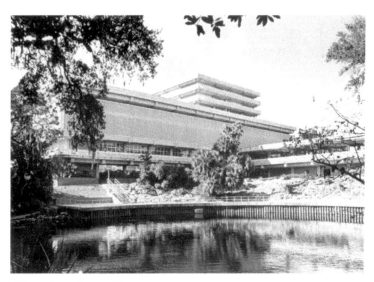

J. WAYNE REITZ STUDENT UNION.

Student union facilities for the rapidly growing university were greatly expanded by the construction of this building, named for the university's president from 1955 until 1967. They moved from the antiquated Dauer Hall rooms, which had served since 1937.

UNITARIANS

At a meeting of fifteen individuals on the university campus, a decade of philosophical discussions began that evolved into a program of religious education. By 1962, it was organized into the Unitarian Universalist Fellowship of Gainesville and meetings were moved into the Hotel Thomas. After its meeting room there was damaged by a flood, gatherings were moved to the Seventh Day Adventist Church, where it met from 1963 until 1967. Members were active in the movement for civil rights.

In 1967, the fellowship moved into a new building on NW 43rd Street. At the time, the membership roll listed eighty-seven individuals. In 1997, it moved again, to 4225 NW 34th Street, where it had available a choir room, infant room and more classrooms and offices than it had at its previous location.

UNIVERSITY OF FLORIDA

J. Wayne Reitz was named to the Board of Agricultural Consultants of the Rockefeller Foundation, and became a member in 1964 of the Public Advisory Committee for Trade Negotiations. He announced his resignation in early 1967 and was succeeded by Stephen C. O'Connell, who was the first UF graduate to become the school's president. To

STEPHEN C. O'CONNELL.

Stephen C. O'Connell served as the university's president from 1967 until 1973. His years were marked with campus unrest over the country's participation in the Vietnam War and the school administration's discrimination against black students.

take over as head of the university, he resigned his post as chief justice of the Florida Supreme Court. One of the most important decisions of the court during his tenure there had directly affected the University of Florida, by preventing its integration through rejection of Virgil Hawkins as a student because of his race.

The decade included a continued effort to construct dormitories for students. The end of the 1960s saw demonstrations both in favor of and opposed to the Vietnam War.

THE 1970s

BUCHHOLZ HIGH SCHOOL

In 1923, a school building was erected at 723 W. University Avenue and served as Gainesville High School until 1955. That year, it became Buchholz Junior High School, named for Fritz W. Buchholz, an Alachua County teacher, principal, scholar, coach, author and politician. The school board resolved that if the school were ever abandoned, the name would be transferred to another school. That happened in 1972, when the new Buchholz High School opened at 5510 NW 27th Avenue.

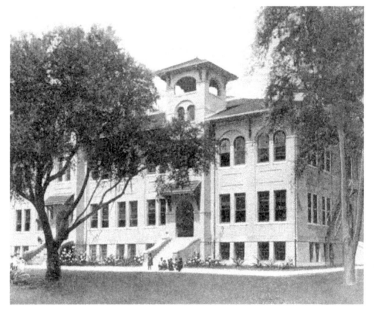

BUCCHOLZ JUNIOR HIGH.

This 1921 building served as Gainesville High School until 1955, when it became Buchholz Junior High to honor a beloved local educator. The Buchholz name was transferred in 1972 to a new high school located a few miles to the northwest.

SANTA FE COMMUNITY COLLEGE

The establishment of a community college to be located in northwest Gainesville was approved in 1965. It included revolutionary educational concepts, such as treating vocational and adult programs as equals with college classes and allowing students to repeat courses to eliminate previous incomplete grades of "W." Classes on the 115-acre tract began in 1972 under President Dr. Joseph Fordyce, and branch campuses have opened in the years since then.

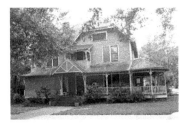

BODIFORD HOUSE.

One of the many historic preservation projects undertaken by Historic Gainesville, Inc., was this 1898 home of druggist James Bodiford. After the home was saved from demolition, it was sold with restrictive covenants to preserve it for the future.

HISTORIC GAINESVILLE, INC.

In 1972, residents of the northeast section of Gainesville formed Historic Gainesville, Inc., to save their neighborhood from deterioration and preserve its older homes. It acquired an option to lease the Hotel Thomas, which was then purchased by the city and restored in a joint effort among citizens and government. Other properties were saved from demolition by the organization, and preservation efforts resulted in the Northeast Historic District being placed on the National Register on February 19, 1980.

NEIL BUTLER

The first black city official since before 1900 was Neil Butler, who became a member of the city commission in 1969. In 1974, he became Gainesville's mayor, the first black man to hold that post since Josiah T. Walls in 1876.

DEVIL'S MILLHOPPER

Designated a State Geological Site in the mid-1970s, the huge sinkhole at 4732 NW 53rd Avenue (aka Millhopper Road) is visited by about fifty thousand people each year. Prior to its being acquired by the state, the

DEVIL'S MILLHOPPER.

This huge sinkhole turned into a state park provides an environment resembling something from the Northern United States or Canada, rather than Florida. It has also been a source of sharks' teeth and fossils. The postcard is from 1908.

land was owned by the University of Florida.

The hole is 500 feet across and 120 feet deep, and is estimated to have formed between 14,000 and 20,000 years ago. Underground limestone deposits eroded, formed a cavern and when the roof caved in the land above dropped. A 221-step wooden stairway was constructed in 1976, saving the sides from the erosion caused by people climbing down the unprotected dirt. It also saved visitors from potential injury by eliminating the steep climb on slippery rocks and roots.

The sinkhole's shape resembles a hopper used in a gristmill to feed grain into its grinder. It was named for the devil for two reasons. Some believed that sinkholes were the product of the devil. Others thought that this particular sinkhole was formed by the devil trying to escape from the earth's surface, or to trap people and bring them underground. The Devil's Millhopper is the centerpiece of a park of sixty-three acres, including walking trails and an exhibit of locally found sharks' teeth and fossils.

OAKS MALL

The largest shopping center in north central Florida was developed by Alan Squitieri and opened in February of 1978, west of downtown Gainesville along Newberry Road. Oaks Mall's sixty initial stores and size made it roughly double that of the previous main shopping center, the Gainesville Mall.

UNIVERSITY OF FLORIDA

At the beginning of the decade, the university experienced racial problems. Technical integration had begun in 1958, but the proportion of black students was miniscule. It was felt by many that black enrollment was not being encouraged. A sit-in at President

The School of Architecture was established in 1925 within the College of Engineering, and was involved in the design of campus buildings. A portion of its own complex of six buildings, the first of which opened in 1965, is shown here.

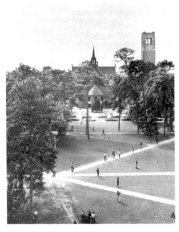

PLAZA OF THE AMERICAS.

This wide expanse of grass, pathways and benches, defined by a boundary of stately old Collegiate Gothic–style brick buildings, is a comfortable place to study, relax, eat lunch or hold outdoor concerts.

O'Connell's office in early 1971 resulted in sixty-six arrests, and when a request for total amnesty was rejected a third of the black students left the school.

Stephen O'Connell retired in 1973 and was succeeded by E. Travis York Jr., who had been the provost for agriculture and executive vice-president. The next permanent president was Robert Q. Marston, who took over in 1974. He was an advocate for integration and affirmative action, and oversaw the reorganization of a large part of the university, including the establishment of the College of Liberal Arts and Sciences, the College of Fine Arts and the Eminent Scholars Program.

The last of the "temporary" Flavet residences were finally razed in 1974. Construction of several married housing projects, including Maguire Village, University Village South, Corry Village and Diamond Village, provided the needed living space to take over for

the dilapidated military units. On the site of some of the Flavet homes was later built the three-story brick Apartment Residence Facility on Stadium Road for upper-division and graduate students.

In 1975, plans were developed for a sports arena and activities center. Construction continued on it throughout the remainder of the decade. The Institute of Food and Agricultural Sciences was established, largely through the efforts of E.T. York.

THE 1980s

HISTORIC DISTRICTS

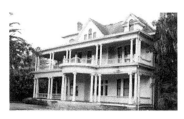

GRACY HOUSE.

The designation of four historic districts not only recognizes the existence of structures of historical importance, but also focuses attention on the need to preserve them, such as this 1906 home of Luther Gracy, located in the northeast district.

During the 1970s, the activities of Historic Gainesville, Inc., in preserving several old buildings raised the awareness of the city's residents as to the importance of saving its historic sites and areas. During the 1980s, that movement resulted in the designation of four historic districts that were added to the National Register on the dates shown below:

NORTHEAST GAINESVILLE RESIDENTIAL DISTRICT (February 12, 1980), bounded by NE 1st and 9th Streets and E. University and NE 10th Avenues.
SOUTHEAST GAINESVILLE RESIDENTIAL DISTRICT (January 14, 1988), bounded by SE 9th Street, Sweetwater Branch and E. University and SE 2nd and 8th Avenues.
PLEASANT STREET HISTORIC DISTRICT (April 20, 1989), bounded by NW 1st and 6th Streets and NW 2nd and 8th Avenues.
UNIVERSITY OF FLORIDA CAMPUS HISTORIC DISTRICT (April 20, 1989), bounded by U.S. 441/SW 13th Street, North-South Drive, W. University Avenue and Stadium Road.

UNIVERSITY OF FLORIDA

In 1981, the Student Activities Center was dedicated and named for former President Stephen C. O'Connell. It is used for Gator basketball games and entertainment programs.

In 1984, Marshall Criser succeeded Robert Q. Marston as the university's president, and during his administration UF became a

O'CONNELL CENTER.

The 1980 opening of the O'Connell Student Activity Center allowed Gator basketball games to be moved from the old Florida Gymnasium. In addition, the facility includes a swimming pool and several other venues for physical activity. *Photo by the author.*

member of the Association of American Universities. Criser had left his law practice in West Palm Beach, served five years as president during a period of relative financial stability and expansion and then left to practice law in Jacksonville. For the last year of the decade, UF was led by Interim President Robert A. Bryan, who had served the previous ten years as the university's provost.

After a winless 1979 football season, the Gators began a streak of winning seasons and bowl invitations. In 1984, the team went 9–1–1 and earned its first ever Southeastern Conference championship. Galen Hall was named the conference's Coach of the Year. However, the NCAA completed its investigation of prior rule violations, with the announcement of 107 violations (later reduced to 59). The NCAA imposed severe penalties, but did not take away the SEC championship. The SEC Commission also voted to let UF keep the championship, but that was overturned by the SEC Executive Committee. The team went 9–1–1 again in 1985 and wound up ranked fifth nationally and, but for the probation, would have been the official SEC champion.

THE 1990s

GAINESVILLE-HAWTHORNE STATE TRAIL

The State of Florida acquired old rail bed leading eastward from Gainesville in 1988 and 1989, and on it developed the Gainesville-Hawthorne State Trail Park. Except for the initial portion that follows a curving route from Boulware Springs westward along the edge of Paynes Prairie, the trail follows the paths of several railroads to end in downtown Hawthorne.

UNIVERSITY OF FLORIDA

During most of this decade, the university was led by President John V. Lombardi, previously the provost and vice-president for academic affairs at Johns Hopkins University. In 1999, he was succeeded by Charles E. Young, who for twenty-nine years had been the leader of UCLA.

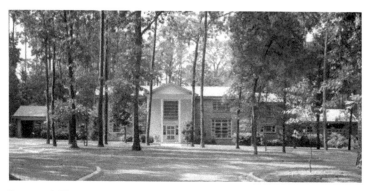

PRESIDENT'S HOUSE.

President John Tigert used his private home to receive faculty and distinguished visitors, but a larger house located on campus was needed. The first president to occupy this home was J. Hillis Miller, who led the university from 1948 until 1953.

The football team won its first national championship in 1996 by defeating Florida State 52–20. It was led by quarterback Danny Wuerffel and was coached by UF alumnus Steve Spurrier, each of whom won the Heisman Trophy in his senior year. Five years earlier, the Gators won the first Southeastern Conference championship that they were allowed to keep. That was followed by additional conference championships in 1993, 1994, 1995, 1996, 2000 and 2006.

The Evelyn F. and William L. McKnight Brain Institute opened, complementing the existing medical facilities. It brought the UF medical program to world prominence, involving three hundred faculty members from ten colleges.

THE TWENTY-FIRST CENTURY

ALACHUA COUNTY COURTHOUSE

In 2001, it was decided that Alachua County needed a new courthouse, and a 6.2-acre site was selected at 220 S. Main Street. Seven century-old structures were on the site (along with more recent ones), and opportunities were afforded for their removal. Only one, a dentist's office, was moved to another location before the others were razed. Three of the buildings were taken apart and the old materials, including oak and pine flooring, bricks and fixtures, were salvaged for use in other buildings.

The new courthouse was designed by the DLR Group, Inc., and built by a team headed by general contractor PPI Construction

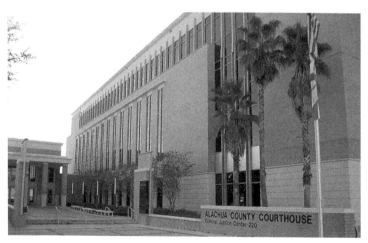

ALACHUA COUNTY COURTHOUSE.

This large courthouse is Gainesville's fifth, and the first one not located on Courthouse Square. It occupies the block that served for decades as the Tebeau School, and handles the county's criminal court functions. *Photo by the author.*

Harn Museum.

In addition to being one of the Southeast's largest university art museums, the Samuel P. Harn Museum of Art is evidence of the departure from the Collegiate Gothic style of campus buildings of the first half of the twentieth century, and the plainer rectangular brick buildings of the second half. *Photo by the author.*

Management, Inc. The building is used chiefly for criminal matters, while the previous courthouse adjacent to the Downtown Community Plaza remains the venue for most civil actions.

University of Florida

Charles Young was president of UF until 2003, then was succeeded by J. Bernard Machen, formerly the president of the University of Utah. He leads a school of nearly fifty thousand students and an endowment of over $836 million. He aims to enhance the educational experience, encourage economic development throughout Florida, promote diversity on campus and improve the school's relationship with the environment. The university intends to continue its focus on teaching, research, technology and athletics.

The Gators men's basketball team won its first NCAA championship in 2006, the university's first major sport national championship since the football team won one a decade before. On January 8, 2007, the Gators won their second NCAA football national championship by beating the Ohio State Buckeyes, 41 to 14. In doing so, the University of Florida became the first school ever to simultaneously hold national championships in men's basketball and football.

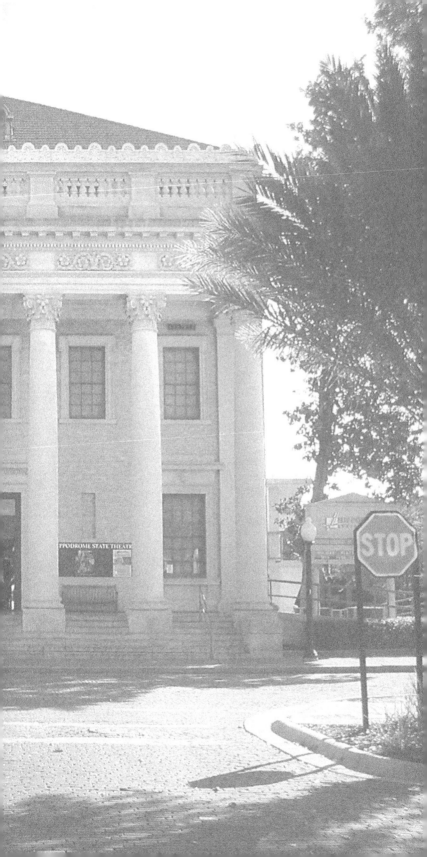

PART TWO:

STREET GUIDE

STREET GUIDE

Following is a list of sites that are historically important because of what was built there, what happened there or who lived there. Included are buildings and other features that still remain, plus a few others that are merely memories. Those that no longer remain are marked with asterisks.

This guide covers several historic Gainesville streets, focusing on those closest to downtown. Most structures are private residences, commercial establishments or school facilities, closed to general public access. Although they may be enjoyed from the outside, grounds and interiors are not available without the owners' prior permission.

MAIN STREET

15–17 N. MAIN STREET

First National Bank of Gainesville. On June 1, 1888, First National Bank of Gainesville opened its doors for the first time at this location with assets of $1,001.13. It was the only Gainesville bank to survive the Great Depression. In 1954, it moved to another building across Main Street and a little to the north. Above the front door at 15 N. Main Street is the three-dimensional logo of a clipper ship, representing Atlantic Bank. The building is now the home of a nightclub known as the Atlantic.

33–37 N. MAIN STREET

Brown House. In this three-story brick building was the Brown House hotel, conveniently located across the street from the Atlantic Coast Line Railway passenger station. It later was the home of the Canova Drug Store and other offices and retail establishments. By the 1940s, the lodging was known as the Gilbert Hotel. Uses after 2000 include the public defender's offices and a restaurant.

104 N. Main Street

First National Bank. On August 23, 1954, First National Bank moved to this site, in a new two-story concrete building with a granite front. In later years, it was known as Atlantic First National Bank and First Union, and in 1973 it moved next door to a seven-story building now housing Wachovia Bank. The 1954 building was then demolished. The site was previously the location of the Atlantic Coast Line ticket office, which moved out in 1948, the same year the railroad tracks were removed from Main Street. The railroad had decided that it was better to have the tracks a half-mile to the west, where they would not have to contend with the forty-five-foot steep slope along S. Main Street, which consumed a lot of fuel to run.

215 N. Main Street

Masonic Temple. The Masonic Lodge organized on January 15, 1857, and first met in a room above the fire station at the corner of SW 2nd Avenue and 1st Street, then moved to the Dutton Bank on W. University Avenue. There were strong ties between the local Freemasons and the Jewish community, so Jewish High Holy Days services were held there. The Masons bought this site (where an Episcopal church had been built in 1873) in 1903 and built the present temple, which was dedicated on April 28, 1909. Its cost, including furnishings, was $16,500. It has a Beaux-Arts Classical style with Doric columns supporting a raised portico, sheltering doors with Masonic sunburst designs.

404 N. Main Street

Home of Thomas Thomas. In 1871, one of Gainesville's five practicing physicians was Dr. Thomas Fraser Thomas. He and his family lived here on the second floor, and he also operated a hardware store and funeral business. The latter became the Thomas-Williams Funeral Home in 1954 when Thomas's business merged with that of Dick Williams.

411 N. Main Street

Citizens Bank. Citizens Bank opened on December 3, 1947, at 110 E. University Avenue. In 1953, it sold that property to the city, bought this site and erected the present building in 1964 for $430,000. It later became the home of Sun Bank, later known as SunTrust. In earlier years, on this land was the home of the Bishop family, which was used as a girls' dormitory of the East Florida Seminary until it became part of the university in 1906, then was remodeled by Major William R. Thomas into the White House Hotel (also briefly known as the Oaks Hotel). While the Atlantic Coast Line Railway had its tracks on Main Street, passengers often stopped at the White House for meals before the train continued on to the station. The White House was expanded with a two-story wing to increase its capacity to two hundred guests in 1913. The hotel was torn down in 1962 to make room for the bank.

8 S. MAIN STREET

Bauknight Building. J.P. Bauknight bought a brick building located here in the 1870s. Later, the site was occupied by the Belk Lindsey Department Store.

104 S. MAIN STREET

Commercial building. Previously, this was the site of S.B. Duke's Saloon, which was replaced by this building. By 1900, it contained a doctor's office and four stores. During the 1930s, it housed the University Furniture Company, which as City Furniture lasted into the 1960s. It became the Main Street Cocktail Lounge in 1976, and continued as a nightclub until 1996.

108 S. MAIN STREET

Livery stable. After 1904, this was the site of the Pound Livery Stable. Later, the Western Auto Store was located here.

109 S. MAIN STREET

Porter-Haymans-Woodbridge Building. From the early 1900s until 1926, this brick building was the home of the *Gainesville Daily Sun* newspaper, for much of the time sharing it with Burtz Printing, the publisher of city directories. In the 1930s and 1940s, the United States Tung Oil Laboratory was located here. Other tenants have included an art studio, beauty salon, cafeteria and a variety store.

111 S. MAIN STREET

Billiards parlor. By the 1890s, this was the site of a two-story masonry barn that housed a furniture store, a cabinet shop and the Dell & Pound Livery Stable. That building was replaced in about 1912 by a garage of the Gainesville Chevrolet Company. The dealership moved out during the early 1930s and the building was divided into one portion for Melton Motors, Inc., and the other for Cypress Inn Billiards. In 1950, the two sections were reunited and housed the Johnson Brothers Seed & Feed Company. Eight years later it became Stud's Pool Hall, which later was replaced by Happy Hour Billiards.

113 S. MAIN STREET

Office building. This was built in the late 1880s as a meat market, then later housed a cigar factory, tin shop, tailor shop, retail stores, welding shop and the Wayside Press, a print shop. Johnson Brothers, the seed and feed company that occupied the building just to the north, also used this one from 1950 until 1958. Later, this was converted to a professional office building. One of its tenants has been the Eleanor Blair Studio.

115 S. MAIN STREET

Tench Building. Built in 1887, this was the Samaritan Hotel during the 1890s. It
served passengers on the Savannah, Florida and Western Railroad, whose
tracks ran by the front of the building. It also served as a plumbing office, a
gunsmith store, a Chinese laundry and professional offices. It received the
name Tench when Dr. J. Dawkins Tench opened a dental surgery office on
the second floor. In it was also located the law office of Benjamin Tench
beginning in 1949, long before he became a circuit judge. One of the
building's tenants after 2000 was the Tench Art Studio and Gallery.

120 S. MAIN STREET

Commercial Hotel. This three-story structure was built in 1885 as the Alachua
Hotel, facing both Main Street and the Savannah, Florida and Western
Railroad track. It was renamed White's Hotel in 1892, the Seminole Hotel in
1910, the Imperial Hotel in 1920 and the Commercial Hotel in 1924. For the
first two decades of the twentieth century, it housed the Hill Printing Company
and the Pepper Printing Company. During the late 1970s, it was donated to
Alachua County and, in 1981–83, it was modified for use as a county office
building, and presently serves as the Alachua County Administrative Annex.
It is the oldest remaining building in Gainesville that began as a hotel.

220 S. MAIN STREET

Alachua County Criminal Justice Center. This courthouse was built in 2001–03
and handles all levels of criminal matters from traffic infractions and
misdemeanors to felonies. Until 1951, this block was the site of the Tebeau
School. As early as 1949, proposals were made to construct a courthouse on
this site, with Courthouse Square being turned into parking, stores and a
park surrounding the Confederate memorial. Voters turned that down by a
margin of three to one, and the new courthouse was built on the square in
1958–62, followed by another in 1976.

400 BLOCK OF S. MAIN STREET

Haisley Lynch Gardens. Mary Helen Lynch deeded this land to the city with the
stipulation that it would be used as a park. It is named for her son, Haisley
Lynch, who was Gainesville's only World War I citizen killed in action. He died
on November 18, 1918, the day the armistice was signed to end the war.

602 S. MAIN STREET

Cox Warehouse. This warehouse was constructed in about 1890 with a triple
arched entrance and a side access large enough for railroad cars to enter
and conduct loading and unloading indoors. It was used by the Cox
Furniture Company and as a wholesale grocery warehouse, then after

years of abandonment was converted to offices in 1994. It resembles a small Romanesque Revival church with the taller central portion allowing clerestory lighting. It is listed on the National Register of Historic Places.

619 S. MAIN STREET

Baird Hardware Company Warehouse. Built in 1910, this served as the main warehouse for the Baird Hardware Company. The one-story building is masonry vernacular in style, and after Baird moved out it was divided into subspaces for small businesses. It was added to the National Register in 1985 and has been the home of a repertory theatre company, the Acrosstown Repertory Players.

UNIVERSITY AVENUE

8–16 E. UNIVERSITY AVENUE

Vidal Building. This was the home of the drugstore owned and operated by Dr. Adolph J. Vidal, then continued after his death by his son.

26–30 E. UNIVERSITY AVENUE

Wilson's Department Store. A department store first opened for business at this location during the 1870s. In 1909, a group of local citizens incorporated and formed Wilson's. It was named for the family of Lemuel Wilson, the registrar of the U.S. Land Office in Newnansville and one who helped attract the University of Florida to Gainesville. One of Wilson's co-owners was Charles A. Colclough, who moved from South Carolina in 1875. The building on this corner is now the home of the Greater Gainesville Visitor and Convention Bureau.

APPROXIMATELY 100 E. UNIVERSITY AVENUE

Clock tower. The second courthouse in Gainesville was constructed of brick in 1886 and had a clock tower. The clock, made by the Seth Thomas Clock Company in 1885, connected to the town fire alarm system so all could be alerted in the event of a fire. Although the building was torn down in the early 1960s, the clock was saved and in 1983 it was placed in a new forty-six-foot-tall tower funded by donations. It was constructed with a style similar to that of the original 1880s courthouse tower out of hand-molded brick and concrete. Ted Crom restored the original clock to working order.

200 E. UNIVERSITY AVENUE

Municipal building. This facility was built at a cost of $1,900,000 on the site of the Baptist Church, the last portion of which was torn down in

1965. This facility was dedicated on April 14, 1969, and serves as the city hall. It was designed by Myrl Hanes Associates, Dan P. Branch and David R. Reaves, and was built by general contractor Guy E. Cleveland Construction Company. It underwent a major renovation in 1992–96.

201 E. UNIVERSITY AVENUE

Community Plaza. As part of the bicentennial observance on April 3, 1976, this square was dedicated as the Community Plaza. It was designed by university architect Harry Merritt and built for $250,000, which came mostly from donations. Many of the bricks were formerly part of the buildings that had stood on the site, and other recycled materials were included to tie the plaza to early Gainesville. It was remodeled in the 1990s to make it more appropriate for activities. It is adjacent to the Alachua County Family/Civil Justice Center, which handles most non-criminal legal matters.

222 E. UNIVERSITY AVENUE

City hall annex. This $439,000 building opened in 1969 as the Gainesville branch of the Santa Fe Regional Library, and is commonly known as the "Old Library." It had 17,500 square feet of space, too small even when it was new. It was superseded by a more modern library in 1991, located across University Avenue to the east. Adjacent to the building is the beautifully landscaped Martin Luther King Memorial Garden.

401 E. UNIVERSITY AVENUE

Gainesville Public Library. The library was located here from 1918 until 1968. The original building was funded by a $10,000 grant from the Carnegie Corporation. It was replaced by a new building in 1956 on the same site. The library moved to another location across University Avenue in 1968, then came back to this site and an $11 million facility completed in 1991. It opened with 78,500 square feet and a capacity of 200,000 volumes. Prior to libraries being established on this site, here sat the city's first public school for white children, erected in 1885.

418 E. UNIVERSITY AVENUE

Christian and Missionary Alliance Church. This building was erected in 1935 as the Gainesville Gospel Tabernacle, housing the Christian and Missionary Alliance Church led by Pastor H.J. Biddlecum. The congregation later moved out and the building was turned into a restaurant.

513 E. UNIVERSITY AVENUE

Matheson Historical Center. This Georgian Revival building was designed by Sanford Goin and completed on November 11, 1932, as the home of the Haisley Lynch Post No. 16 of the American Legion, which had organized in 1919. Previously, this was approximately the site of the Tabernacle, a two-thousand-seat structure completed in 1906 for the Florida Winter Bible Conference. On November 11, 1993, this building became the city archives and museum. Behind it is Sweetwater Park, including walkways and a dozen large display panels explaining the city's history.

607 E. UNIVERSITY AVENUE

Home of Barney Colson. This house with a style adapted from traditional Queen Anne was built in 1904 for Barney R. Colson, who three years before had affiliated with the Alachua County Abstract Company and also founded the Florida Land and Title Company. In 1977, this building was converted to a law office. The unique attic window is fashioned out of colored glass in diamond-shaped panes.

617 E. UNIVERSITY AVENUE

Home of Reed McKenzie. This is an elaborate Queen Anne–style home with shingle and horizontal siding, a polygonal tower and a projecting gable at the main entry door. It has an attached one-story gazebo and a widow's watch room in the third-floor turret. It was constructed in about 1895 by John R. Lambeth, and in 1925 was acquired by Reed and Mary Phifer McKenzie and their family. Reed owned a motor company. Other families who lived here included the Colsons, Bakers, Phifers and Pounds, many of whom were related to each other. In 1980, it was adapted for use as offices. Two years later, it was added to the National Register.

620 E. UNIVERSITY AVENUE

Kirby Smith School. This school was built in 1900 as the Gainesville Graded and High School. In 1923, it was renamed Eastside Elementary School. In 1939, it was remodeled, the two main buildings were connected and it was renamed after General Edmund Kirby Smith (1824–1893), the last survivor of the full generals of the Confederacy, who was born in St. Augustine. His troops in Texas were the last in the Confederate army to surrender, which they did on May 26, 1865 (more than six weeks after Lee's surrender at Appomattox Court House). The school was converted into an adult education center and the main office of the Alachua County School Board in 1977.

625 E. UNIVERSITY AVENUE

Home of Alonzo Cushman. This Victorian-style home was erected in 1885 by Alonzo Cushman from Massachusetts, who for a time was Gainesville's fire chief. Dr. James Colson bought the home in 1905 and served as the president of the Alachua Medical Society. Later, it was operated as the Alvarez Tourist Home for forty-five years. In 1992, it was converted to use as a seven-room bed and breakfast establishment known as the Sweetwater Branch Inn for the small stream located nearby.

631 E. UNIVERSITY AVENUE

**Home of John Alderman.* Located here was the home of Dr. John Hiram Alderman of Melrose, Florida, who moved to Gainesville in 1901. He operated a dental office located in the 400 block of W. University Avenue and was a Ford automobile dealer. Despite becoming blind for the last ten years of his life, he was still able to enjoy fishing as a hobby.

639 E. UNIVERSITY AVENUE

Salvation Army. The University Avenue Church of Christ organized in 1897 and met in a building at the corner of NE 1st Street and 6th Avenue. The congregation then moved to 313 E. University Avenue, and on June 1, 1955, moved to this building. It later became the home of the Salvation Army.

708 E. UNIVERSITY AVENUE

Home of James Doig. In about 1882, this home was built by James Doig with an Italianate style. Doig had a previous home on this property during the 1860s, at a time when his was the farthest home east on what is now called University Avenue. He established the Doig Foundry and Machine Works in 1859 and was the first man in Florida to build a complete locomotive. He also participated in the First Battle of Gainesville during the Civil War. In 1867, he became a city alderman. His iron foundry was located near the railroad depot during the 1880s. After 1923, the home was turned into a boardinghouse and then back to a single-family residence. During 1982, this home was converted to professional offices by Jean and Terry Marshall.

755 E. UNIVERSITY AVENUE

Home of William Dorsey. Built in about 1900, this was the home of grocery store and bakery owner William S. Dorsey and his family from 1913 until 1973. It has an enclosed courtyard and a smaller additional building in the back. During the 1970s, it was converted for use as law offices.

805 E. UNIVERSITY AVENUE

Home of James Fowler. This is a Queen Anne Victorian–style home, built in about 1906 by real estate broker James R. Fowler. He served as a county commissioner, a member of the chamber of commerce and mayor in 1925–26. His business interests included Gainesville's first gas station and first Buick sales agency. The house features six fireplaces and a round tower arising out of a circular gazebo.

810 E. UNIVERSITY AVENUE

Home of Andrew Howard. Built in 1883 as the winter home of Andrew Howard, a Pittsburgh manufacturer of glass, it was modernized and enlarged in 1903–04. It was converted in 1925 by McKee Kelley to serve as a boardinghouse known as the Lodge. In 1941, Ben Crawford renamed it the Crawford Tourist Lodge. The Salvation Army turned it into its headquarters in 1969, and in 1987 it was transformed into professional offices by Mark and Mary Barrow. Howard had served as the president of the Alachua Steam Navigation and Canal Company, whose steamships hauled freight across Paynes Prairie when it was a lake.

815 E. UNIVERSITY AVENUE

Home of Henry McCreary. This home was built elsewhere in 1890 with a Victorian style featuring a Palladian window, second-story bay and a large gable in the front. In 1879, journalist Henry Hamilton McCreary moved to Gainesville and eventually became the publisher and editor of the *Gainesville Bee.* McCreary continued to lead the newspaper after it became the *Gainesville Sun*, until 1917. The McCreary family continued to occupy the home until 1974, and it was moved the following year to this site to save it from being torn down.

824 E. UNIVERSITY AVENUE

Home of Oscar Durrance. This large home was built in about 1914 and was acquired in 1946 by Oscar and Mattie Durrance. He served as the postmaster and was a founder of the First Federal Savings and Loan Association. The Durrance family lived here until 1982, when the home was purchased by Eilon Kurgman-Kadi, who converted it into a law office. Inside, the flooring is made from bird's-eye maple and there is a shower in the basement.

3000 E. UNIVERSITY AVENUE

Loften Center. This land was purchased by the federal government as a site for a veterans' hospital. That facility was instead constructed on Archer Road, and this land was then acquired by the school board and a school was erected upon it. Included was a vocational program that grew into a high

school, and it was named the W. Travis Loften Education Center after an educator with more than forty-five years of service in Florida.

3540 E. UNIVERSITY AVENUE

Morningside Nature Center. This wildlife sanctuary includes a living history farm with an 1840 cabin, the one-room Half Moon School, an 1880s twin-crib barn, reproduction outbuildings, a 1900s board and batten kitchen and 278 acres of woodland covered with walking trails. It is a way to see what north central Florida was like before it was settled by Europeans, and how the early settlers subsisted on their crops.

2 W. UNIVERSITY AVENUE

Gainesville National Bank Building. Located here was the wooden three-story, two-hundred-room Arlington Hotel, which hosted notables such as Teddy Roosevelt and Ulysses S. Grant. The building was destroyed by a fire in May of 1884. The wooden hotel was replaced by a brick building constructed by Marcus Endell and his brothers as a dry goods store. The Gainesville National Bank moved in during 1907 and on the second floor was the Gainesville Guards Armory. Woolworth's moved in during 1923 and stayed until 1982. It has also been the home of the Chesnut Office Equipment Company and a restaurant.

20–22 W. UNIVERSITY AVENUE

Dutton Bank Building. Built in about 1885, this brick building was the home of one of Florida's earliest private banks, the Dutton Bank, and the H.F. Dutton Company, the city's then-major mercantile company. One of the company's featured products was the Doig Cotton Gin. The Masonic Lodge met on the third floor, which was added in 1888. After the Masons moved to their own building in 1908, other secret societies used that space until 1922. The bank was acquired in 1914 by the Gainesville National Bank.

105 W. UNIVERSITY AVENUE

**Blacksmith shop.* During the 1920s, a blacksmith shop was located here. The sidewalk in front had horse and mule shoes imbedded in it, placed there by C.C. Pedrick, who during the 1880s had a wagon and buggy shop at 20 SW 1st Street and a blacksmith shop at 103 SW 2nd Place. Later at this site was Cherry's Dress Shop.

106 W. UNIVERSITY AVENUE

**Chesnut Office Supply.* A building that stood here was the home of Gainesville's first office equipment company, founded by James Gibbes Chesnut. It

featured arts and crafts as well as office supplies. Chesnut's was located at this site until the early 1980s, when it moved to the northwest corner of W. University Avenue and Main Street.

120 W. UNIVERSITY AVENUE

Florida National Bank. The Phifer State Bank was founded on December 18, 1913, by brothers Henry and William B. Phifer. Its original location was at 23 SE 1st Street. In 1946, it was renamed as the Florida Bank at Gainesville, and later as Florida National Bank.

124 W. UNIVERSITY AVENUE

First Federal. Upstairs at this location in 1936, First Federal Savings and Loan Association of Mid-Florida opened for business. In 1939, it moved to two rooms at 307 W. University Avenue, and six years later it moved to 329 W. University Avenue. In 1957, it moved again, to 249 W. University Avenue.

201 W. UNIVERSITY AVENUE

**Bond Jewelry.* In the 1940s, this was the home of Bond Jewelry, owned by Frank Lewis, who also owned Lewis Jewelry across the street. This building has also been the home of Lamar Hatcher's Florida Gift Shop. The J.C. Penney Company opened its first Gainesville store here on September 21, 1956, and remained here until the opening of the Oaks Mall.

214 W. UNIVERSITY AVENUE

Primrose Square. This building started out as a university professor's home in 1910, then was converted to the Primrose Inn and Grill in the mid-1920s by Byron Winn Sr. It closed its living spaces during the early 1960s, and remained a popular eating establishment until May 8, 1988. It was then turned into an office complex. It resembles some Prairie-style buildings with its false half-timbering, and combines a first floor of fieldstone and a second of shingles to produce an interesting combination.

233–35 W. UNIVERSITY AVENUE

Florida Theater. On September 10, 1928, this two-story brick theater opened and remained as the city's most popular place to view movies until the 1960s. It was the first Gainesville theater to show "talkies" in its 1,100-seat auditorium. Until the days of desegregation, black individuals were not allowed in the theater. It was converted to use for live performances as the Great Southern Music Hall, reopening as such in 1974. Seats were replaced by a dance floor in 1990, and it remains in use as a nightclub. Its architecture includes several Colonial Revival elements such as

Corinthian columns, sunburst patterns within the arched windows and turned balusters.

239 W. UNIVERSITY AVENUE

Wise's Drug Store. The drugstore was founded by Joe Wise Sr. in 1938 and was initially located elsewhere on this block. In 1958, it moved next door to the Florida Theater. It had the last old soda fountain in downtown Gainesville.

268 W. UNIVERSITY AVENUE

Shaw and Keeter Ford Building. During the 1930s, this was the home of the Shaw and Keeter Ford sales agency, following its being occupied by the Robuck Motor Company until 1923. In the 1970s, it was the disco known as Nichol's Alley, then Lone Star, a country music dance hall. That was followed by the Caribbean club Islands, Skeeter's restaurant, a bumper car amusement hall and another restaurant.

300 W. UNIVERSITY AVENUE

Firestone Garage. The present garage, now unused, sits on the former site of the home of Walter Robinson, built during the 1860s.

408 W. UNIVERSITY AVENUE

John F. Seagle Building. This is downtown Gainesville's single skyscraper, known over the years as the Kelley Hotel, the Dixie Hotel and the Seagle Building. The only taller buildings in Gainesville are the university's Beaty Towers. The lower floors are sheathed in stone and the upper ones are stuccoed. It was added to the National Register in 1982.

413 W. UNIVERSITY AVENUE

**Marshall House.* In early Gainesville, a Mr. Marshall had a log cabin here, constructed by 1850. Later, a Sinclair filling station was located on the site, now occupied by the Gainesville Lodge Motel.

425 W. UNIVERSITY AVENUE

First Baptist Church. In 1921, the congregation of the First Baptist Church voted to purchase this land and erect a new sanctuary. They had Newbald L. Goin and J.E. Green design it for them with a Classical Revival style, and during 1923–24 it was built by J.L. Penny and F.H. Winston at a cost of $150,000.

723 W. University Avenue

Gainesville High School. This was the site of Gainesville High School, finished in 1922 at a cost of $80,000. It later served as the F.W. Buchholz Junior High School, named for the high school's principal.

1002 W. University Avenue

Georgia Seagle Hall. Built in the mid-1930s, owner Georgia Seagle Holland operated this residence in 1938 as a home for the University of Florida football team for a year, then as a boardinghouse. It passed in 1943 to the Florida Conference of the United Methodist Church as trustee, for operation as a nonsectarian Christian facility to provide needy university students with a low-cost place to live. It was later operated by a bank, and then by an association formed by alumni who had lived in the building, to provide low-cost housing to university students who performed house maintenance services. It is now known as Paradigm Hall.

1257 W. University Avenue

Sigma Alpha Epsilon house. On this corner was located the home of the Sigma Alpha Epsilon fraternity, the university's fourth Greek organization, whose local chapter was established in 1915. In the front yard of the house was a cast cement lion that was the target of pranks by other fraternities involving tar and feathers, paint, sledgehammers and even dynamite. By the early 1960s, the SAEs followed the trend of moving to fraternity houses on campus. So did the Pi Kappa Alphas, whose house on the northeast corner was torn down to make way for a Holiday Inn.

1738 W. University Avenue

St. Augustine Church. This congregation began in 1922 when a chapel was built on this site. Called St. Thomas Chapel, it was run by the pastor of St. Patrick's Catholic Church. The chapel seated 50 people and adjacent to it was a Catholic student residence, Crane Hall. As the student population grew in the 1940s, the church was expanded by the construction of a temporary wooden chapel, and then by the replacement of the old buildings with a new sanctuary. Named for St. Augustine, it was dedicated on December 13, 1959, with 750 seats. St. Augustine received its own pastor in 1969, with a mission to serve the students, families and workers affiliated with the University of Florida.

2809 W. University Avenue

Gainesville Woman's Club. The Twentieth Century Club, which was renamed the Gainesville Woman's Club in 1960, was founded in 1903 and its first president was Mrs. N.D. Phillips. The club raised funds for the city's first

library and in 1915 obtained a Carnegie grant to construct a library building. The club had its home beginning in 1921 in a new building erected for $11,078.75 at 700 W. University Avenue and moved to its present location in 1961. The 1921 building was then moved to 4039 NW 16th Boulevard to house the Gainesville Community Play House.

NE BOULEVARD

531 NE BOULEVARD
Home of Clara Gehan. Sanford Goin designed this home, built in 1939 with a Cape Cod style. Its exterior molding showed youths playing musical instruments and maidens picking flowers. Clara Floyd Gehan lived here and was the first female to graduate from the University of Florida Law School when she received her law degree in 1933. Her husband, Freddie Gehan, taught children's literature at the university.

532 NE BOULEVARD
Home of Hattie Roebuck. In 1937, this red brick home was built as a duplex by Hattie Roebuck. Five years later, it was purchased by Myrtle Geiger, who then owned a women's clothing store. The house has a Georgian Revival style and in 1989 it was converted into a single-family residence. It features a trio of dormer windows and a pedimented main entryway.

634 NE BOULEVARD
Home of Paul Tietgens. A Mr. McDonald designed this Prairie-style home resembling the Primrose Inn. There are large overhanging eaves, a brick base and a shingled second story. Until 1938, it was the home of oil businessman Paul Tietgens. After that, it was acquired by the Harrison family.

708 NE BOULEVARD
Home of James Farr. This Colonial Revival–style home began as a part of the dairy barn of Major William Reuben Thomas. His cows, whose milk supplied the White House Hotel, grazed along Sweetwater Branch. The barn was cut in half during the 1920s and moved to make room for the construction of the Hotel Thomas. Beginning in 1925, it was the home of James Farr, who had headed the English Department at the university's Lake City campus. Later in Gainesville, he taught English, was the school's first football coach and served as vice-president and acting president of the university. The house was sold in 1936 to James B. Adkins, whose company manufactured boxes. For a time, it also housed the private Loblolly School.

714 NE BOULEVARD

Home of Harry Trusler. This was one of the first homes constructed along NE Boulevard, a Mission-style house of the 1920s. It has a typical flat roof and parapeted walls, plus an unusual triple-arched masonry porch that forms a carport. It was the home of Law School Dean Harry Trusler and his wife, Anna, for more than four decades.

730 NE BOULEVARD

Home of Frank Surface. This is a stucco-covered Mediterranean Revival home built in 1926. It features a pair of decorated chimney tops, twisted Corinthian pilasters and arched windows. It was the home of economist and Standard Oil executive Frank Surface and his wife, Anna Bunger, beginning in 1955.

914 NE BOULEVARD

Home of Warren Welch. This Tudor Revival home was built in 1926 with a half-timbered front gable and a stucco-on-wood exterior. For nearly four decades, it was the home of Warren Welch, a vice-president of the Pepper Printing Company.

NE 1ST STREET

100–10 NE 1ST STREET

Holy Trinity Episcopal Church. This Gothic Revival church was built in 1903–07 of limestone masonry, replacing a wooden church located at the corner of University Avenue and Main Street. This land on which it sits was donated to the church by a Dr. Porter. The walls were built with cement, coral rock and crushed granite applied over brick. A 1950s hurricane damaged some of the stained-glass windows, which were restored through the efforts of the women of the congregation. A particularly attractive one is a three-part window in the east façade that represents the Trinity. A substantial portion of the church was rebuilt after a 1991 fire.

117 NE 1ST STREET

**City hall.* Gainesville's three-story city hall was built for $71,500 here in 1927, the same year the city government was restructured to change from a seven-member city council to a city manager and commission. The building was constructed of cream-colored brick and marble, and the police department and jail occupied the basement. A tall safe had entrances from two of the floors. To raise some income for the city during the Great Depression, the building was rented to the Rural Resettlement Division and municipal employees moved to other rented space. That not only provided the city with $200 monthly rent, it also brought a federal agency to town with a large

payroll. The city hall building was torn down in 1968 to make room for a parking lot for the new city hall. Previously on the site was the Gainesville House hotel, torn down in 1926.

218 NE 1ST STREET

Home of E.F.C. Sanchez. Colonel E.F.C. Sanchez lived here in 1876. Evans Haile and Colonel Irving E. Webster brought the controversial presidential ballot box from Archer to spend the night in Gainesville, before the final vote count was made. The contents were allegedly tampered with here or at the home of L.G. Dennis, giving a slight majority to Republican presidential candidate Rutherford B. Hayes.

APPROXIMATELY 418 NE 1ST STREET

Fellowship Hall. This building was constructed at this site in 1886 as part of the Kavanaugh Memorial Church. The church was an outgrowth of the Methodist Society, which had been organized in 1854 and was later renamed the First Methodist Church. The first church building had been erected in 1859 on a lot bought from the county for five dollars, and another was built in 1875. Services were conducted in what is now known as the Fellowship Hall until 1942.

419 NE 1ST STREET

Epworth Hall. Not long after the Civil War, this land served as a campsite for a company of soldiers from the United States Colored Troops. White occupation troops took their place by the end of 1865. The present building known as Epworth Hall was built in 1884 with a Renaissance Revival style and served as the home of the East Florida Seminary until it merged with the University of Florida. On the first floor were four classrooms and upstairs were a study hall, offices and library, and the main entrance was through the tower on the south side of the building. When the university campus moved to Gainesville in 1906, Epworth Hall was used as its temporary campus. The building was purchased by the Methodist Church in 1911 and its entrance was moved to its west end. It has been listed on the National Register since 1973. The name Epworth comes from the English hometown of John and Charles Wesley, who founded the Methodist denomination.

529 NE 1ST STREET

Home of Henry Gray. This home was built in about 1903 with a Colonial Revival style. Typical for its period, it has small lap siding. It was acquired by lumberman Henry L. Gray in 1905, and he extensively remodeled it. Gray died in 1921 and in moved his daughter, Ottie Gray Morrison, and her dentist husband, Dr. Donald Morrison.

617 NE 1ˢᵀ STREET

First Advent Christian Church. This is a Gothic Revival–style church built in
about 1909. In 1888, its congregation had been formed in Hague, Florida,
as the Second Advent Christian Church. This building is a T-shaped
Gothic Revival structure with stucco above brick. It features a pyramidal
bell tower, painted arched windows and an arched entrance with unusual
spiral pillars.

622 NE 1ˢᵀ STREET

Home of Thomas Stevens. This home was built in 1910 for bank bookkeeper
Thomas Stevens, who lived in it with his family until 1926. From 1942
through 1982, it was the home and office of realtor Ina Joe Wrench. In
1984, it was converted to law offices. The style is Colonial Revival and
features Tuscan columns supporting a wraparound porch and curved arches
in the joint dormers.

636 NE 1ˢᵀ STREET

Home of Lee Graham. This bungalow was built in 1913 by S.A. Ledbetter with a
Craftsman style. When it underwent substantial restoration in later years, its
original leaded-glass windows were preserved. Beginning in 1914, it was the
home of banker Lee Graham, who served as a city commissioner. Members
of his family were still living here during the 1970s.

703 NE 1ˢᵀ STREET

Home of Aaron Da Costa. This home was built in about 1895 by Judge Aaron
J. Da Costa, who served as tax assessor and a U.S. commissioner. He and
members of his family lived in it until the 1950s. The Martha Manson
Academy held classes here in the late 1960s, and in 1972 it was turned
into law offices. Originally, the home was surrounded by a double veranda,
which has since been removed.

719 NE 1ˢᵀ STREET

Home of Washington Fennel. This home was built in about 1900 with a frame
vernacular style. From 1920 until the 1940s, it was the home of sheriff and
citrus grower L. Washington Fennel and his wife, Alma. Their daughter,
Myrtle T. Waldo, played the organ in the Methodist Church for forty years.
The next residents were their grandson, attorney George Selden Waldo,
and his wife, Tommy Ruth Waldo, who played the First Baptist Church
organ for more than twenty years. In 1981, the house was converted to use
as a residence and law office.

725 NE 1ˢᵗ STREET

Home of Beemun family. This home was built in 1908 for the Beemun family, and was sold two years later to James Vidal, who designed the Duck Pond area nearby. The home was later converted to a law office.

NE 2ᴺᴰ AVENUE

404 NE 2ᴺᴰ AVENUE

Home of James Jolly. James Jolly built this Queen Anne–style home in 1903 with unmatched cross gables and an extended veranda. The long, sloping roof and deep overhang provided shade in the summer and protection from rain. It was later the home of Seaboard Coast Line superintendent Harry O. McArthur.

516 NE 2ᴺᴰ AVENUE

Recreation Center. The federal government in September of 1942 offered to construct a facility for recreation so long as the city would provide the site and operate the center. This lot was chosen and was used for recreation by men stationed at the Alachua Army Airbase, which had a flight school. The Soldier Service Center had its formal opening on July 23, 1943, and the city reacquired the air base in 1946. In more recent years, it has been known as the Thelma A. Boltin Activity Center, named for a Gainesville High School speech and dramatics teacher who served as the facility's first program director. After the war, it was known as the City Recreation Center and hosted dances and other activities.

NE 3ᴿᴰ AVENUE

204 NE 3ᴿᴰ AVENUE

Former Methodist Church. This building served as the First Methodist Church from about 1874 until 1887, when it became the church's social and lecture hall. It was converted into a single-family home in 1900 when the east wing with three bedrooms, sun porch and bathroom was added. After World War II, it was operated as a boardinghouse. It deteriorated, and was restored by Maurice and Karen Williams in 1986.

316 AND 317 NE 3ᴿᴰ AVENUE

Mirror images. These two homes were mirror images of each other when they were built in about 1905. Since then, the porch on the southern one has been enclosed.

NE 3ʳᴰ Street

206 NE 3ʳᴰ Street

Home of James McCollum. In 1905, druggist James W. McCollum had this cottage, built in about 1880, substantially remodeled for his wife, Caroline. It has a Queen Anne–style with lapboard siding and a turreted roof atop a gazebo-style porch. It was later the residence of his widow, "Aunt" Carrie McCollum Palmer, until 1978.

215 NE 3ʳᴰ Street

Home of Benjamin Richards. This Queen Anne–style house was built in 1895, and two years later was acquired by Benjamin P. Richards and his wife, Clara Jordan, whose brother, Birkett Fry Jordan, lived across the street. She was instrumental in the establishment of the Kirby Smith School. He was a bank cashier and owned a pecan grove. This home has been referred to as the "spool house" because of its extensive turned wood decoration.

216 NE 3ʳᴰ Street

Home of James Bodiford. In 1897–98, druggist James Strange Bodiford built this home with an Eastlake Victorian style to mirror the Benjamin Richards home. Bodiford had arrived in Gainesville in 1878, moved to Cedar Key and sold medicine there until 1890, then returned to Gainesville and ran a drugstore until he died in 1934. He also served as the president of the Florida State Pharmaceutical Society. To protect the home from demolition, it was acquired in 1978 by Historic Gainesville, Inc., which in turn sold it with protective restrictive covenants. It was later converted to four apartments but retains its original appearance, including the interesting diamond-shaped fish-scale siding on the second-floor balcony.

306 NE 3ʳᴰ Street

Home of Albert Blanding. In 1899, this Queen Anne–style house with gingerbread trim was built for Horatio Davis, who served as a two-term mayor. It was acquired by General Albert H. Blanding, a graduate of the East Florida Seminary who moved in during 1922. In 1936, he was appointed by President Roosevelt as the chief of the National Guard Bureau. Camp Blanding, the large military installation created near Jacksonville at the beginning of World War II, is named for him. Blanding was instrumental in the creation of the Everglades National Park, and was only the second Floridian to attain the rank of general. Blanding moved out in 1958. This was originally a single-family home, and in 1980 was converted to a pair of apartments.

307 NE 3RD STREET

Home of Birkett Jordan. This home was built in 1897–88 with a Greek Revival style, featuring a Chinese Chippendale balustrade. Birkett Fry Jordan erected it between the homes of his sisters, Mary Ellen Hampton and Clare Jordan Richards. Mr. Jordan founded B.F. Jordan & Co., a Gainesville insurance business, and owned a grove near Micanopy. He was also an officer of the Alachua Steam Navigation Company, whose business on Alachua Lake ended with the draining of the sinkhole and reappearance of Paynes Prairie. In the mid-1970s, the house became vacant, was vandalized and was nearly torn down. In 1983, Katy Morgan restored it and turned it into a duplex.

321 NE 3RD STREET

Home of Louis Barnes. On this lot, a home was built during the 1890s by Louis A. Barnes, the registrar of the only U.S. Land Office in Florida. He paved the road and lined it with trees. In 1896, the house was purchased by William Wade Hampton, the attorney who handled the transfer of the University of Florida to Gainesville. The house was torn down in 1977.

324 NE 3RD STREET

Home of L.G. Dennis. Formerly located here was the home of L.G. Dennis, containing his office, which may have been where he or other conspirators stuffed the ballot box in the 1876 presidential election. The late results from Alachua County gave Rutherford B. Hayes a slim margin over Samuel Tilden, resulting in a Republican victory. Dennis also owned the Dennis Block, the two-story business block, a portion of which was occupied by the East Florida Seminary after its first major fire in 1883. Other occupants of the commercial building were the offices of the city council and the mayor's court.

BETWEEN NE 4TH AND 5TH AVENUES

Roper Park. This city park served as the parade grounds of the Gainesville Academy, which became state-supported in 1853 and later merged with the University of Florida. It is named for James Henry Roper, who established the academy. It has also been known as City Park and Barracks Park.

425 NE 3RD STREET

Home of William Hampton. This board and batten siding house was constructed in about 1880 at 314 NE 4th Avenue (where in 1904 a home was built for Luther C. Gracy). It was moved here in about 1900 and served as the home of attorney William Wade Hampton Jr. and his family for more than seventy-five years. Hampton practiced law with his father, who lived a block away.

NE 4ᵀᴴ Avenue

205 NE 4ᵀᴴ Avenue

Home of Robert Livingston. This rectangular Queen Anne–style home was built during the 1890s. It includes an ornamental railing above a bay window, an upper balcony and a corner porch gazebo. In 1905, it was acquired by city commissioner and ice dealer Robert B. Livingston. He lived there until 1940, and thereafter it was owned by other members of his family.

314 NE 4ᵀᴴ Avenue

Home of Luther Gracy. In 1904–06, the Colonial Revival–style house was built for Luther C. Gracy, with a design created by the architectural firm of Barber and Kluttz of Knoxville, Tennessee. Gracy was a civic leader, lumberman and turpentine dealer. He handpicked the lumber for the house from his own inventory, including pine (heart, rosemary and curly), oak, magnolia and pecan. He was an ardent abolitionist, and Carry Nation visited him in this home, as did William Jennings Bryan. The home was later remodeled as apartments.

404 NE 4ᵀᴴ Avenue

Home of Wilmon Newell. This Colonial Revival home was built in 1887 and was enlarged by successive owners. From 1920 until 1968, it was owned by Dr. Wilmon Newell, an entomologist who was involved with the eradication of the Mediterranean fruit fly from the United States. Newell altered the house by enclosing the front and sleeping porches in 1930. The hip roof and gable porches are Colonial Revival in style, and the home has an unusual second-story bay window.

405 NE 4ᵀᴴ Avenue

Home of W.B. Denham. In 1898, Captain W.B. Denham and his wife, Carrie, built this Queen Anne–style house with a wraparound porch. Major William Reuben Thomas and his wife, Katy, lived here from 1900 until 1909 before they moved to the Sunkist Villa portion of what is now the Thomas Center. Later, this home was owned by the Webb family. The low stone wall and carriage block are original.

414 NE 4ᵀᴴ Avenue

Home of Sinclair Eaton. This cottage was built about 1884 and features a steeply gabled roof and Victorian-style ornamental trim. It is memorable for its unusual bracketed pediments and ornate bay window. It was the home of the Gillis and Eaton families, including insurance agency owner Sinclair Eaton and his wife, Ruth, beginning in 1938.

417 NE 4TH AVENUE

Home of A.J. McArthur. In 1897, this Shingle-style home was built by city fire chief A.J. McArthur. The stone porch and castellation were added beginning in 1913 by University of Florida business manager Klein Graham. Graham worked for the university from 1906 until 1948, and may have added the stone details to emulate some found on campus buildings. In 1972, it was restored by new owner Robert Jester, who reopened the enclosed porch. The home has an unusual four-foot-wide Dutch door as its main entrance.

NE 4TH STREET

516 NE 4TH STREET

Home of George Kelly. This home was built in 1913 for music store and lumber mill owner George H. Kelly, featuring a prominent front dormer and broad porch supported by square columns. It was operated by sisters Mary Ellen and Louise Swords as a boardinghouse and family-style restaurant from 1952 until 1984. The home was purchased by Steve Raid, who as a university student used to eat his meals here for ten dollars a week.

711 NE 4TH STREET

Home of Bill Pepper. This home was built in 1935 as a wedding present for Bill Pepper and Kathryn Tucker. It initially had no stove, and the newlyweds ate their meals at restaurants or next door, with his parents. Once the Peppers had children, they added a stove. It became a rental property later in 1935.

1024 NE 4TH STREET

Home of M.M. Parrish. Built in 1948, this is a Southern version of a Cape Cod home and was the residence of M.M. Parrish Jr. It features a massive barrel tile roof.

NE 5TH AVENUE

305 NE 5TH AVENUE

Home of William Hill. This is a Colonial Revival–style house, built elsewhere in 1912. It was the home of William Hill, secretary of U.S. Senator Duncan Fletcher during the 1930s, and upon Fletcher's death Hill was appointed to serve out the rest of his term. The home was sold in 1931 to Stella Kidd and in 1966, the First Methodist Church purchased it to be used as parish offices. In 1991, the deteriorated house was moved across Roper Park to its present location and restored.

306 NE 5ᵀᴴ AVENUE

Home of Albert Murphree. This Greek Revival/Southern Colonial–style house was built in 1911–13 as the home of James H. Holder, whose businesses were turpentine and lumber. He sold it to Albert A. Murphree, University of Florida president from 1909 until 1927, who used the home as the center of university social life. The house has Ionic columns and leaded-glass windows. The second-floor balcony was used by visitor William Jennings Bryan to deliver speeches to residents and university students. In 1936, the home was acquired by Arthur Carlos Tipton, and later owners divided it into seven apartments. A 1975 purchaser began the long process of restoring it to its original appearance.

406 NE 5ᵀᴴ AVENUE

Home of James McKinstry. This Victorian-style cottage was built in 1880 for Dr. James F. McKinstry, a doctor who also served as the postmaster from 1915 until 1921. For nearly three decades, it was the home of Dr. Robert Bowman, a dentist. It was later acquired by Sam Gowan, the first president of Historic Gainesville, Inc., who was instrumental in the preservation of the Hotel Thomas. It is a simple one-story frame vernacular home with drop siding and cross gabling.

506 NE 5ᵀᴴ AVENUE

Home of William Phifer. This Colonial Revival–style home was built in 1903 by William B. Phifer, a prominent civic leader and businessman. He was the brother of Henry Phifer and partner in the Phifer Bros. Department Store and the Phifer State Bank. The Corinthian porch columns on this house are made from solid cypress.

540 NE 5ᵀᴴ AVENUE

Home of William Thomas. In 1932, this brick Colonial Revival–style house was built for physician Dr. William C. Thomas, who lived here from the time it was completed until he died in 1974. The home was designed by Ralph Sandiford with Tuscan columns and a stone quoin entryway.

608 NE 5ᵀᴴ AVENUE

Home of Herbert Taylor. This home was built in 1904 and was the residence of Herbert E. Taylor, president of the First National Bank. This house was considered to be located on the highest ground in early Gainesville. The house features a patterned tin roof and large front gable and during the 1940s, it was the home of Cecil and Peggie Gravey. A later owner, professor Aubrey Williams, added an English garden and restored the home beginning in 1958.

NE 5TH STREET

420 NE 5TH STREET

Home of Henry Phifer. In 1897, newlyweds Henry Landon Phifer and Mary L. Ridenhour built this Queen Anne–style home with a wagon wheel motif and sunburst design in the gables. Phifer and his brothers founded the Phifer State Bank and Phifer Bros. Department Store, which later became Wilson's Department Store. Henry Phifer also served as Gainesville's mayor from 1923 until 1925.

NE 6TH AVENUE

205 NE 6TH AVENUE

Home of William Steckert. This home was built in 1903 by lumberman William R. Steckert, vice-president of the Gainesville National Bank. It was converted into a duplex in 1949, and modifications that year included the reduction of the size of the porch. Interesting features include the double-bay window on the west side and the stained-glass windows.

305 NE 6TH AVENUE

Home of Finley Cannon. This was originally built in 1912 as a rental property by Edmenson E. Cannon and later was the home of his son, E. Finley Cannon Sr., and his wife, Louise De Pass. Finley founded an insurance agency and served as the president of the Chamber of Commerce and Rotary Club. The Cannons remained in the house until 1975, and Andrew Kaplan remodeled the home into a duplex in 1986.

306 NE 6TH AVENUE

Thomas Center. This south section of this large building was begun by Charles W. Chase, the manager of the Dutton Phosphate Company. It was completed in 1910 and in moved Major William Reuben Thomas, who was involved in the relocation of the University of Florida to Gainesville. The northern (hotel) portion was designed by William A. Edwards, and was built in 1926–28. When completed, it became the social and political gathering place of the community. The southern portion was converted to a restaurant, which closed in 1968.

319 NE 6TH AVENUE

Home of Matthew DePass. This two-story stuccoed home was built in 1926. It was the residence of Dr. Matthew DePass, who was the chief of staff at Alachua General Hospital. From 1963 until 1997, it was the home of psychology professor Richard Anderson.

403 NE 6ᵀᴴ AVENUE

Home of Everett Yon. This home was constructed about 1900 and during the 1920s became the home of Everett Yon, the university's athletic director. It was sold in 1931 to the children of the university's second president, Albert A. Murphree. The home was occupied by English professor Audie Murphree from then until 1986, when it was restored by the McGill family. The house is asymmetrical with three sections of gables, showing a blend of styles found in many Queen Anne structures.

NE 6ᵀᴴ STREET

406 NE 6ᵀᴴ STREET

Home of Edward Cooper. This is a frame vernacular house with a cross-gabled hip roof. It was built in 1909 for Edward Cooper, an accountant and treasurer of the Baird Hardware Company. A later occupant was Willie Adele Metcalfe, principal of the Kirby Smith School. The home was divided into apartments in 1948.

424 NE 6ᵀᴴ STREET

Padgett Apartments. This structure was built as a house in 1904. Not long afterward, it was converted to apartments run by Carrie Padgett. In 1980, it was restored by Mary Barrow to its original Colonial Revival appearance as a single-family residence with a projecting central pavilion, Palladian windows and a symmetrical façade.

514 NE 6ᵀᴴ STREET

Home of Charlton Melton. Known locally as the Rock House, this was built by developer W.H. Edwards in 1935. Its exterior is covered with limestone quarried near High Springs, in which can be found fossils and shell fragments. From 1942 until 1961, it was the home of real estate agent Charlton Melton.

NE 7ᵀᴴ AVENUE

114 NE 7ᵀᴴ AVENUE

Home of Caleb Layton. This home was built in 1895 with a Queen Anne style, lapboard siding and octagonal fish scales. Ten years later, it was purchased by Colonel Caleb R. Layton, a banker and attorney who served as mayor and a member of the school board. In 1981, the house was converted into a trio of apartments by Katy Morgan.

406 NE 7ᵀᴴ AVENUE

Home of William Pepper. This home was originally one half of the dairy barn of Colonel William Reuben Thomas, located on the grounds of the present Thomas Center. When this was converted into a residence in 1924, it was done with a Colonial Revival style and ornate shingles. It was the home of William M. Pepper, who owned the company that published the *Gainesville Sun* from 1917 until 1941. He and his wife, Sarah, had two sons who took over the newspaper in 1941 and continued it until 1962.

NE 7ᵀᴴ STREET

210 NE 7ᵀᴴ STREET

Home of Louise Bowers. This is a two-story Colonial Revival home built in 1913 with double Ionic columns, a metal gabled roof and a pair of bay windows. It was the home of Louise Bowers and her family for nearly five decades.

NE 8ᵀᴴ AVENUE

AT WALDO ROAD

Citizens Field. This was the home field of the G-Men, a minor league baseball team of the 1930s through the 1950s. The team won the Florida State League championship in 1949.

2106 NE 8ᵀᴴ AVENUE

Charles W. Duval Elementary School. This began as a one-room schoolhouse in 1937, and was named after the local shoemaker who donated five acres of land so it could be built.

NE 8ᵀᴴ STREET

120 NE 8ᵀᴴ STREET

Home of J.H. Allison. J.H. Allison built this home in about 1914 with a Colonial Revival style and unusual roofline. The enclosure of the porch may have taken place in a later year.

NE 9ᵀᴴ AVENUE

207 NE 9ᵀᴴ AVENUE

Home of William Shands. This home was built in 1895 and during the 1940s was modified to add a brick façade and large columns. It was the home of

William Shands from 1941 until 1953, when it was purchased by insurance salesman E. Finley Cannon.

214 NE 9ᵀᴴ AVENUE

Home of M.M. Parrish. This Colonial Revival–style home was built in 1925 by developer and builder M.M. Parrish, who moved to the area from Kentucky in 1911. Parrish was involved in the development of several neighborhoods, including the Duck Pond area. The house features two matching side extensions with elaborate millwork, plus four sets of square columns supporting the entrance porch. Elma Parrish had a large formal garden in the backyard and grew flowers for weddings, church services and other social events.

515 NE 9ᵀᴴ AVENUE

Home of John Carter. Sanford Goin designed this red brick home, built in 1938 for two families. It features a wrought-iron railing, decorative balustrades on the pair of sunrooms and two matching chimneys. It was the home of John and Vera Carter and her sister, Mrs. Winn, until 1966. During that year it was acquired by education professor Pauline Hilliard.

525 NE 9ᵀᴴ AVENUE

Home of John Pierson. This 1936 vine-covered cottage was built by architect John E. Pierson to resemble a Brittany farmhouse. The thick walls are made of fieldstone and rooms have steeply pitched ceilings up to fourteen feet in height. After about ten years, the Piersons moved out. Later, it was the home of Dr. Perry Foote, who served as dean of the College of Pharmacy.

NE 9ᵀᴴ STREET

304 NE 9ᵀᴴ STREET

Home of William Seigler. This home was built in 1883 with an Italianate style featuring a bracketed cornice, arched windows and a recessed doorway. It was the residence of Dr. William Seigler, a local dentist. Later additions to the home include the two-story porch and carved scroll ornaments.

1901 NE 9ᵀᴴ STREET

Howard W. Bishop Middle School. This school, which opened in 1962, is named for an Alachua County school superintendent. He had previously played fullback on the University of Florida football team.

NE 10TH AVENUE

217 NE 10TH AVENUE

Home of John Maines. Built in about 1919, this is a one-story Tudor Revival–
style home with a steep twin-gable roof. The twin gables are repeated
with one on the detached garage and a buttressed arched opening
leading to the backyard. It was the home of Alachua General Hospital
surgeon Dr. John E. Maines Jr. until 1950, when it was sold to retired
sporting goods store owner Jimmie Hughes.

224 NE 10TH AVENUE

Home of John Tigert. This Colonial Revival house was built in 1929 by
M.M. Parrish Sr. for Dr. John J. Tigert, who served as the president of
the University of Florida from 1928 until 1947. A second university
president, Dr. J. Hillis Miller, lived here after that until the President's
House was completed on the western end of the campus. It features
four tall white columns on the exterior and on the interior, a staircase
resembling one in George Washington's Mount Vernon estate. A later
owner was road contractor L.M. Gray, who lived there until 1960.

NE 14th Street

1028 NE 14TH STREET

Martin Luther King Jr. Multipurpose Center. This facility opened in 1997, the first
recreation center built by the city in twenty-nine years.

NE 15TH STREET

3500 NE 15TH STREET

Marjorie Kinnan Rawlings Elementary School. This school is named after the
renowned Alachua County author of *The Yearling.*

NE 18TH AVENUE

1250 NE 18TH AVENUE

W.A. Metcalfe Elementary School. This school is named for Willie Adele
Metcalfe, who was the principal of the Kirby Smith School and
has been described as one of Gainesville's best-loved teachers and
principals.

NE 39ᵀᴴ Avenue

3880 NE 39ᵀᴴ Avenue

Gainesville Regional Airport. In 1930, Gainesville acquired 150 acres northeast of downtown and built an airport. Beginning in the late 1930s, Carl Stengel operated his Stengel's Flying School there, and during 1937, 10 percent of the students at the University of Florida were taking lessons from him. The city's airport became the site of the Alachua Army Airfield, which opened shortly after the bombing of Pearl Harbor, so Stengel moved his operation to Stengel Field on Archer Road, on the present site of the Butler Plaza shopping center. Alachua Army Airfield served as a primary flight school and an air support school of applied tactics. In 1948, the airport was returned to the city for civilian use as the Gainesville Municipal Airport. Eastern Airlines began flights to Gainesville in 1950, followed by other major airlines.

NW 1ˢᵀ Avenue

Approximately 25 NW 1ˢᵀ Avenue

**Ogletree Garage.* Located here was the huge brick Ogletree Garage until it burned down on November 18, 1945.

NW 1ˢᵀ Street

320 NW 1ˢᵀ Street

Home of J.C. Chapin. In 1886, this two-story Italianate-style home was built by J.C. Chapin. Decades later, it was transformed into apartments and was allowed to fall into disrepair. The city condemned the building, prepared to tear it down and was stopped in 1984 when the building was bought by Keifer and Sande Calkins. They restored the home and added a two-story porch. It later became the home of a decorating service called Warrington's Fine Interiors.

524 NW 1ˢᵀ Street

Rosa B. Williams Recreation Center. This facility is located on a portion of the former Union Academy grounds, and was dedicated to honor a woman who served her community in many ways. She was a member of the Gainesville Commission on the Status of Women, the Hippodrome State Theater Board, the Board of Directors of Shands Hospital and the local branch of the NAACP. In 1982, she received the *Gainesville Sun* Community Service Award.

NW 2ND Street

426 NW 2ND Street

Friendship Baptist Church. City commissioner Reverend Richard E. Shivey founded this as St. John the Baptist Church. Its first building was erected in 1888 and was destroyed by a fire. It was replaced in 1911 on land provided by Reverend Shivey with the present rusticated concrete block Romanesque Gothic Revival sanctuary. It has served as the meeting place of the Pleasant Street Historical Society. This and the Mount Pleasant United Methodist Church received the Matheson Award in 1997 for their work in preserving the history and heritage of the area.

429 NW 2ND Street

Old Mount Carmel Baptist Church. This church was built in the late 1940s. It is one of several black churches located in the Pleasant Street Historic District, added to the National Register in 1989.

518 NW 2ND Street

Home of Paul Stafford. Dr. Paul Milton Hezekiah Stafford, Gainesville's first black dentist, lived in this house from its construction in 1929 until 1938. Patients used a side entrance to get to his office, inside the home. After he moved out, it was used as a rental property by his ex-wife, and then was renovated during the early 1990s.

620 NW 2ND Street

Mount Pleasant United Methodist Church. Black soldiers and newly freed slaves founded the Mount Pleasant United Methodist Church in 1867, making it the oldest black congregation in Gainesville. For $160, they purchased land from Charles Brush and erected a wooden church by 1884. It and the parsonage burned down in 1903. In 1904–06, they replaced it with the present structure, designed with a Romanesque Revival style. Major features include a two-and-a-half-story tower and intricate stained-glass windows.

727 NW 2ND Street

Dorsey Funeral Home. This building was constructed in 1919 and was used as a restaurant, then in 1932 became the White and Jones Funeral Home. It was operated by Azzie Jones and Reverend D.E. White, the pastor of Friendship Baptist Church beginning in 1939. In 1961, Arnold D. Dorsey affiliated with the company and three years later bought out White's interest in it. The business operated by Mr. and Mrs. Dorsey was later named after them. It later became the Pinkney-Smith Funeral Home.

730 NW 2ND STREET

Home of J.C. Metts. This Queen Anne–style home was built in about 1891 with large brick columns, marginal flashed glass and applied carving on the front door. Over the years, the front porch has been enclosed and a second story was added. Metts operated a grocery store, then a pool hall and then a movie theater, which burned down in 1938.

NW 3RD STREET

116 NW 3RD STREET

Home of Minot Saunders. This home was built with a Queen Anne style in 1897 with a steep pyramid roof with gingerbread and gables. It was acquired in 1904 by merchant Minot "Miny" Bacon Saunders of Bridgeport, Connecticut, who with partner Edward O'Donald had one of the region's largest grocery stores. Purchased from Phillip Miller and Company during the 1880s, it was located on the southeast corner of E. University Avenue and 1st Street.

320 NW 3RD STREET

Home of Alexander Whittstock. The Eastlake style is exemplified in this home from about 1887, with carved posts, an intricate roofline and porches with brackets. It was built by Alexander E. Whittstock, a master carpenter, blacksmith and investor in real estate.

505 NW 3RD STREET

Home of Maud Glover. This house was built in about 1920 at 413 NW 6th Avenue. The simple frame vernacular cottage was owned by Maud Glover from 1950 until 1966. It was moved here and restored to its original appearance during the late 1990s.

721 NW 3RD STREET

Home of Scrivens family. Built in about 1874, this was the home of early postman Mr. Scrivens and his family. It is a one-story frame vernacular house with two matching front gables. Over the front entryway is a gabled ceiling.

NW 4TH AVENUE

102 NW 4TH AVENUE

Home of J.R. Eddins. This Queen Anne home was built in about 1901 by J.R. Eddins. In 1922, it became the home of the Crouch family, who kept it until 1988. Thereafter, the home with the wraparound veranda, bracketed columns and pavilion roof was renovated by Sande and Kiefer Calkins.

110 NW 4TH AVENUE

Home of F. Thomas. This home was built in about 1894 for Dr. F. Thomas. Its Queen Anne elements include an asymmetrical porch supported by Ionic columns and a pyramid roof. In 1960, it was renovated by Reba Lee Bryan, a founding member of the Pleasant Street Historical Society.

116 NW 4TH AVENUE

Home of J.H. Tuttle. Carpenter J.H. Tuttle built this home for himself in about 1897 with a Queen Anne style. A later owner was piano tuner James Clark. In 1986, the house was remodeled with the addition of decorative woodwork along the gable and ornamentation on the bargeboards.

214 NW 4TH AVENUE

Home of John La Fontisee. This home was built in about 1889, probably by Wade Geiger. From 1894 until 1925, it was the home of Gainesville Guards member John La Fontisee and his family. He had arrived in Gainesville in 1886 and had twelve children. One daughter, Caroline, ran a private school in the house in about 1908.

232 NW 4TH AVENUE

Home of Annie Davis. This one-story home from about 1875 has wagon wheel brackets and turned porch details, elements of the Queen Anne style. One of its several owners was Annie Davis.

319 NW 4TH AVENUE

Home of Samuel Hendley. This home was built in 1909 with a frame vernacular style. It was the home of a man who ran a grocery store and served as a deacon of the Friendship Baptist Church, Samuel H. Hendley.

NW 4TH PLACE

412 NW 4TH PLACE

Masonic Lodge. The Rising Sun Lodge #10, F&HA, was chartered in 1870 and built a meetinghouse in 1891. It and other black fraternal organizations met in the present lodge house, which was rebuilt in 1960.

NW 4TH STREET

303 NW 4TH STREET

Home of Julius Parker. This house was constructed in about 1877, the year future Dr. Julius W. Parker was born in it. After attending medical school in Tennessee and practicing medicine for a time in Oklahoma, he returned to Gainesville to operate the Parker Drug Company and treat patients, one of the first black physicians to do so. The home was later owned by a dentist, Dr. Edgar Cosby, who married Parker's daughter. Its original location until 1910 was on the same lot, but a bit to the east of its present position.

429 NW 4TH STREET

Pleasant Hill Baptist Church. Holy Trinity Episcopal Church erected its first sanctuary in 1873 at the intersection of University Avenue and Main Street. That building was moved here to serve as the St. Augustine Mission. It was purchased in 1988 by the Pleasant Hill Baptist Church, which had been founded by Reverend W.G. Mayberry on September 13, 1987.

502 NW 4TH STREET

**Lincoln Theater.* The site of the once-popular black theater is now occupied by Plummer's Barber Shop. In earlier years, that business was located at 743 NW 5th Avenue and catered chiefly to a black clientele.

626–28 NW 4TH STREET

Garrison Nursery School. During the mid-1930s, a nursery school was built here with WPA funds. It was run by Bessie Marie Garrison, who also operated a boarding school for young women. Some of her tenants were women who had moved from outlying areas to attend school.

710 NW 4TH STREET

Home of Sam Cook. This home was built during the 1880s by Sam and Fannie Cook with a frame vernacular style. Sam was a carpenter and the brother-in-law of Jennings Feltner, the city tax assessor in 1888. When built, the house had a side gable. Later, the gabled porch was added.

732 NW 4TH STREET

Dunbar Hotel. This was built in about 1936 as a one-story house, then was expanded by Jackson and Sophronia Dunbar into a two-story rooming house. The Dunbars and their thirteen children lived in cottages located behind the hotel. Their guests included black performers such as Duke Ellington and Count Basie, who came to town to perform at Wabash Hall.

After desegregation, the need for a black hotel decreased and it went out of business and then was abandoned. In 1988, it was renovated and made into a home for pregnant and homeless teenage women.

NW 5TH AVENUE

737 NW 5TH AVENUE

Cato's Sundry Store. This was one of the early black stores, and dealt mostly in snacks. Black residents were limited as to where they could buy land, and this street evolved into the major black business section.

912–18 NW 5TH AVENUE

Glover and Gill Building. In this two-story brick building erected in 1932 was located Walter's Blue Room, a popular place for black residents to dance. It was best known by the name of Wabash Hall. Local black singing groups performed there, and dances and school proms also took place in the hall. Nationally known entertainers including Cab Calloway and Ella Fitzgerald performed there. The hall closed in 1950 and the second floor was converted to apartments. For a time, the building housed a church.

1912 NW 5TH AVENUE

J.J. Finley Elementary School. When this school opened in 1939, it was named for Confederate General Jesse Johnson Finley. He suffered a serious wound at the Battle of Chattanooga and another in fighting at Atlanta. After the war, he served as a member of the U.S. House of Representatives from Florida.

NW 6TH STREET

410 NW 6TH STREET

Railroad depot. During 1948, the railroad tracks along Main Street were removed and the Seaboard Coast Line constructed a depot at this location. After railroad service along NW 6th Street was discontinued, the depot building was acquired by Santa Fe Community College. It was transformed into a downtown campus in 1988, and the nearby Gainesville Gas Building was added to it in 1993.

721 NW 6TH STREET

Police station. The Gainesville Police Department was originally located in the basement of the city hall and placed its prisoners in the county jail. In 1953, the department moved to a new building at this site, which was doubled in size in 1962. This facility, including jail cells, offices and a courtroom, was

built in 1983. It was designed by Salley/Jackson/Reeger, Inc., and was built by M.M. Parrish Construction Co.

1121 NW 6TH STREET

Home of James Bailey. This one-and-a-half-story braced frame house was built between 1848 and 1854 by slave labor for Major James B. Bailey, who sold a portion of his plantation to the county as a site for the courthouse. It is constructed of longleaf pine dressed in a Hogtown mill. This house shows a Frame Vernacular style with Greek Revival elements, and is the oldest surviving house in Gainesville. In later years, it was used as the Bailey Village retirement community. It has been on the National Register since 1972.

3800 NW 6TH STREET

Stephen Foster Elementary School. Named for composer Stephen Collins Foster, this school opened in 1952.

NW 7TH AVENUE

603 NW 7TH AVENUE

Greater Bethel AME Church. This congregation was founded in 1871 and built a sanctuary at this site in 1933. It was rebuilt, producing the present building in 1953.

1108 NW 7TH AVENUE

A. Quinn Jones Center. In 1920, a bond issue was passed for the construction of two high schools, one for whites and this one for blacks. In 1923, the two-story brick Lincoln High School was built here with fifteen classrooms and an auditorium that sat eight hundred. A. Quinn Jones, the last principal of the Union Academy, came here to be the first principal of Lincoln High School. He retired in the mid-1950s and the building was later renamed in his honor.

NW 8TH AVENUE

18 NW 8TH AVENUE

Chestnut Funeral Home. This is the home of the funeral business founded in 1914 as the Hughes and Chestnut Funeral Home. It remains in the Chestnut family.

321 NW 8TH AVENUE

Home of George Smith. In about 1870, George Smith and his wife, Rosetta, moved to Gainesville from South Carolina. They lived in this home with an "I" floor plan, constructed by 1880. It was later occupied by their daughter, Claranell.

NW 13TH STREET

1900 NW 13TH STREET

Gainesville High School. The first Gainesville High School opened on University Avenue in 1905. Funds for the construction of a new school building were approved in a 1920 election and the school moved into it at 723 W. University Avenue in 1921. During the 1930s, its principal was Professor F.W. Buchholz, after whom was named another Gainesville high school. The school at this location opened in 1957 on land donated by businessman Cicero Addison Pound.

BETWEEN NW 29TH ROAD AND NW 30TH AVENUE

Mount Pleasant Cemetery. This cemetery was founded in 1886 and is owned by the Mount Pleasant United Methodist Church. Its five and a half acres contain the remains of many of Gainesville's black residents.

NW 15TH AVENUE

3215 NW 15TH AVENUE

Westwood Middle School. This school opened in 1958 for students from kindergarten through eighth grade. The following year upon the opening of Littlewood Elementary School, Westwood switched to being a middle school.

NW 16TH AVENUE

312 NW 16TH AVENUE

Sidney Lanier Center. This facility opened in 1939 as the Sidney Lanier Elementary School, named for the Poet Laureate of the South.

NW 18TH STREET

16 NW 18TH STREET

Hillel Building. The Hillel Foundation for Jewish university students was founded in 1938 by the B'nai B'rith Lodges of Florida, and later moved to this site. In 1953, the present Hillel Building was constructed to house the foundation.

NW 27ᵀᴴ STREET

5510 NW 27ᵀᴴ STREET

Buchholz High School. The name of Fritz W. Buchholz for a time was applied to the junior high school on W. University Avenue, in the former Gainesville High School building. In 1972, this high school was named after the former high school principal.

DEPOT AVENUE

203 E. DEPOT AVENUE

Railroad depot. This site, just south of the railroad tracks and east of S. Main Street, has had railroad buildings on it since the 1860s. Then, the Florida Railroad passed along the southern edge of Gainesville as it traveled between Cedar Key and Fernandina. That was a relatively short land route enabling freight lines to connect New Orleans with New York with ships loading and unloading on the Atlantic and Gulf Coasts. The railroad tracks reached Gainesville in 1859. The wooden depot was constructed in about 1907. In 1948, the Seaboard Coast Line built a new depot on NW 6ᵗʰ Street, so this depot was no longer used. During the 1950s and into the 1970s, it housed a hardware store and then was used as a warehouse. The former depot was added to the National Register in 1996.

WALDO ROAD

1621 SE WALDO ROAD

Tacachale. This facility was formerly known as the Florida Farm Colony, and then as the Sunland Training Center. Initially, it was primarily a way to keep those who were considered "epileptic" and "feeble-minded" away from the rest of the population. Today, it focuses on the education and employment of its patients.

SE 1ˢᵀ AVENUE

1 SE 1ˢᵀ AVENUE

Scruggs, Carmichael Building. This building is named for a law firm that has occupied it for many years. When it was built in the 1880s, it was known as the Porter Building for owner Watson Porter. The H.M. Chitty & Co. clothing store for men was established here in 1902 by Henry Chitty and Cecil Mathews and remained in business on the first floor until it closed in July of 1970, when it was the oldest Gainesville business with the same continuous ownership. Other tenants have included a dry goods store, bowling alley, restaurant, millinery store and a hardware store.

7–11 SE 1ST AVENUE

Barnes Building. Attorney and U.S. Land Office registrar Louis Barnes built
this business block in about 1887. After 1900, it was occupied by a variety
of businesses including a barbershop, grocery store and clothing stores.
More recently, it has housed a department store, variety store, beauty salon
and restaurant.

19 SE 1ST AVENUE

Baird Theater. This building was constructed by J. Simonson in 1887 to replace
the wooden opera house that burned down the year before, and it was
initially known as the Simonson Opera House. J.F. Edwards purchased
it in 1893 and renamed it the Edwards Opera House. The lower floors
were occupied by stores, including the City Cigar Store and a professional
photographer. Opera and other entertainment took place on the upper
floor, which could seat six hundred. In 1906, Eberle Baird purchased the
building, added a third floor and expanded the auditorium area to a seating
capacity of one thousand. As the Baird Theater, it had live entertainment
and movies until 1929. Gainesville's previous movie theater was located on
the second floor of a building that stood on the northeast corner of SE
1st Street and 1st Avenue. The opera house stood vacant during the Great
Depression, and in 1939 became the home of the Cox Furniture Company.
On the first floor were also located Dorsey's Bakery and the McCollum
Drug Store. The building was renovated and restored during the 1990s to
be a restaurant and offices.

104 SE 1ST AVENUE

Bethel Gas Station. In 1925, this red brick Gulf gas station was built with a
Renaissance Revival style. It is called Bethel for Bethel Honeycutt, the
operator of the station beginning in 1972. In 1974, the city acquired its
site for construction of a civic center, but residents opposed that plan and
the building became a bus terminal. It was moved to the Community Plaza
in 1987 and the white paint (added during the 1930s to make it look more
modern) was stripped off the brick to return it to its original appearance.

111–19 SE 1ST AVENUE

Star Garage. On this site was erected a livery stable in 1903, providing a place
where one could buy and rent horses and buggies. Local residents could
also stable their own horses here. It was known as the Fowler Garage, which
became the home of Poole-Gable Motors. It became the Star Garage in
1917, one of the city's earliest automobile sales agencies, selling Cadillacs
and Studebakers. Upstairs during the 1920s was a paint shop used for
painting airplanes. It was largely rebuilt with a Masonry Vernacular style
following a 1931 fire, and housed the Buick sales agency. Bus companies

used it as a terminal until 1939. The building was purchased by the city in 1977 and in 1986 was turned into offices for attorneys. It was added to the National Register in 1985.

APPROXIMATELY 122 SE 1ST AVENUE

Duval Shoe Hospital. Here was located a shoe repair shop owned by Charles W. Duval, a black community leader. He operated the shop until he died in 1933.

401 SE 1ST AVENUE

Federal building and post office. This facility opened in 1965 at a cost of $2,090,000. Part of the southern portion of the property was once the home of the Southern Bell Telephone and Telegraph Company. Its two-story brick building was constructed in 1948 and included administrative offices, dialing equipment and long-distance operating rooms.

528 SE 1ST AVENUE

Home of James Matheson. This home was built in 1867, incorporating elements of another built a decade earlier. It was the residence of James Douglas Matheson and his family, and was donated to the Historical Center in 1989. It is the second-oldest surviving house in Gainesville and was added to the National Register in 1973.

SE 1ST STREET

12 SE 1ST STREET

Former courthouse. This L-shaped building was erected in 1958–62 to be the new Alachua County Courthouse. It became the Alachua County Administration Building when the new courthouse was built in 1978 at a cost of $4.6 million. At the northwest corner of Courthouse Square is a monument dedicated on January 19, 1904, by the Kirby Smith Chapter No. 202 of the United Daughters of the Confederacy to honor the Confederate soldiers who died during the Civil War. The six-foot-tall bronze infantryman stands atop a stele of Georgia granite.

23 SE 1ST STREET

Phifer State Bank. During the 1920s, this was the home of the Phifer State Bank, established in 1913 by brothers Henry and William B. Phifer. In 1946, it became the Florida Bank at Gainesville, and later the First National Bank. This bank building was demolished in the 1970s to make room for the new courthouse.

101 SE 1ST STREET

Rice Hardware. In 1936, Rice Hardware moved to this location and stayed until 1965.

112–16 SE 1ST STREET

Baird Building. A building located here was the home of Baird Hardware Company beginning in 1890. At that time, the stores on this block made up about half of the business district, with most of the rest being located on the other side of the square. A new Baird Building was erected here of tan brick in 1911 by Eberle Baird and has housed many businesses, including Mike's Bookstore and Tobacco Shop and Lillian's Music Store. During the 1920s, the north side of the building was connected to other buildings as part of the Gainesville Chevrolet Sales Company.

116 SE 1ST STREET

Fire Station No. 1. This is the site of Gainesville's first fire station, erected in 1903. Fires were extinguished by volunteers, and three horses drove the engine. Its first three horses were named John, Mac and Arthur, after an early chief of the volunteer fire department, John MacArthur. The fire department received its first motorized equipment in 1912. On the second floor of the firehouse, the city council and municipal court met until the city hall was completed in 1927. Fire Station No. 1 was later moved to Main Street between SE 4th Place and SE 5th Avenue and the 1903 building was demolished to allow the widening of SE 2nd Avenue from two to four lanes.

APPROXIMATELY 211 SE 1ST STREET

First Presbyterian Church. On December 1, 1859, a $1,200 wooden church opened at this site for the First Presbyterian Church, under the supervision of Reverend W.J. McCormick. Formal organization of First Presbyterian was delayed until after the Civil War. For a time, the Presbyterian sanctuary was shared by all Protestant denominations. Later, the site was occupied by University Chevrolet, a dealership whose building was torn down during the mid-1960s.

212 SE 1ST STREET

Lyric Theater. During the late 1880s, S.O. Weaver ran a laundry approximately at this site. By the end of World War I, it became the location of one of Gainesville's earliest motion picture theaters, the 250-seat Lyric. The Colonial Revival–style building was later occupied by the Jim Hope Electric Company.

SE 2ND AVENUE

12 SE 2ND AVENUE
Sovereign Restaurant. In 1910, this building made from yellow bricks manufactured in Campville served as a carriage house and livery stable for the Baird Theater. When automobiles replaced horses, it became a parking garage. In 1973, it was remodeled to resemble the Court of Two Sisters, a Creole restaurant located in New Orleans's French Quarter. It features a pair of arched openings, an ornamental iron gate and an elevated center parapet. Stained-glass panels and chandeliers were brought to Gainesville from homes in Louisiana.

715 SE 2ND AVENUE
Home of James Hodges. This Queen Anne Revival–style home was built in 1887 at 116 NE 1st Street. After 1900, it was taken down and rebuilt there by physician Dr. James Hodges. A later owner was the Holy Trinity Episcopal Church, which used it as a Sunday school and offices. It was moved to this site to preserve it and make room for a garden, and in 1979 was converted to apartments by Mark and Mary Barrow. Dr. Hodges had been the president of the Florida Medical Society, ran a small private hospital and served as a physician for the university. It was originally a one-and-a-half-story home. The two-story bay, columned porch and side turret were added later.

725 SE 2ND AVENUE
Home of Fagan family. Built in about 1910, this Craftsman-style bungalow is known by the name of the Fagan family, owners of Fagan's Shoe Store. The home sat empty for five years and was condemned before it was remodeled in 1982 by Robert Buel. It has been restored with its four square columns, three bay windows and a three-windowed dormer above the front door.

740 SE 2ND AVENUE
**Odd Fellows Home and Sanitarium.* At this site in 1897 was built a tuberculosis sanitarium, run by the Odd Fellows, a fraternal organization that supported projects for the needy. The building was later used as a girls' school, an orphanage and a home for the elderly before it was torn down in 1974. Its removal allowed SE 2nd Avenue to be extended eastward to Waldo Road.

SE 2ND PLACE

25 SE 2ND PLACE
Hippodrome State Theater. This building, erected in 1909–11, included the post office, which moved out in 1964. In 1980, the interior of the building was

substantially modified to be used as one of only four state theaters. It was placed on the National Register in 1979. The imposing portico with six Corinthian columns capped by orange blossom designs makes it a focal point of the south end of SE 1st Street.

101 SE 2ND PLACE

Sun Center. A building was erected here in 1926 for William M. Pepper, whose Pepper Printing Company published the *Gainesville Daily Sun* newspaper from 1917 until 1963. The Pepper family had been involved in the printing business before coming to Gainesville from Pennsylvania in 1904. William's father, Dr. E.J. Pepper, printed an interdenominational newspaper, religious songbooks and the *Christian Standard* for the Northern Methodist Church. When the newspaper moved out in 1984, the building was transformed into a mall containing restaurants and retail stores, part of the city's $14 million downtown redevelopment efforts. The upstairs offices were remodeled into a two-story atrium to overlook the shops in the interior mall below.

608 SE 2ND PLACE

Home of Edwin Burke. This home was built in about 1941 of fieldstone. Until the 1950s, it was the home of auto mechanic Edwin K. Burke.

615 SE 2ND PLACE

Home of Etienne Lartigue. This home was built by 1893, the year Dr. Etienne Lartigue of Blackville, South Carolina, married Allie Dell and they moved into it. After graduating from the Baltimore School of Medicine in 1897, he returned to Gainesville and began his practice on the second floor of the Vidal Building. Lartigue served as Florida's first public health officer.

SE 2ND STREET

303–17 SE 2ND STREET

**Plaza Hotel.* On this site was the 1890s Plaza Hotel, which faced west and burned down after 1900. It was unrelated to another Plaza Hotel, built at a later time on Main Street.

SE 4TH AVENUE

310 SE 4TH AVENUE

John R. Kelley Generating Station. Originally built in 1914, the original portion of this facility took over the utilities functions of the pump house at Boulware Springs. A major power plant was added in 1947, greatly

increasing the capacity of the Gainesville Regional Utilities Plant. It was renamed in 1965 to honor John R. Kelley, the city's longtime director of utilities.

SE 4ᵀᴴ STREET

115 SE 4ᵀᴴ STREET
Blacksmith shop. Benson and Roux ran a blacksmith shop and carriage factory here during the 1880s. A later occupant of the site was the blacksmith shop of Nells Benson. It was a place to keep one's horses and buggies and have them cared for and repaired.

SE 6ᵀᴴ TERRACE

415 SE 6ᵀᴴ TERRACE
Home of Sigismond Diettrich. This home was built by Lucian M. Gray as part of the Eastview subdivision platted by M.M. Parrish during the 1920s. This one was constructed in about 1930 with a French tile roof and a stuccoed exterior. It was the home of geography professor Sigismond Diettrich for nearly three decades.

421 SE 6ᵀᴴ TERRACE
Home of Howard Garwood. In the 1930s, this was one of the typical bungalows erected in the Eastview subdivision. The home and the detached garage both have a French tile roof and a combination of fieldstone, brick and stucco. During the 1950s, it was the home of Howard B. Garwood.

SE 7ᵀᴴ AVENUE

1245 SE 7ᵀᴴ AVENUE
Joseph Williams Elementary School. In 1938, this school opened and was named to honor a black resident who had petitioned for the establishment of the school. Many of its 150 students came from families of black soldiers stationed at Camp Blanding during World War II. The soldiers often made the twenty-five-mile trip to Gainesville on weekends. Following the war, many settled in Gainesville. This school was attended solely by black students until the early 1970s, when all city schools were integrated.

SE 7ᵀᴴ STREET

15 SE 7ᵀᴴ STREET

Home of James Medlin. This house was built in 1913 of dark brown brick held together with purple mortar, plus interesting white keystone windows. It is a Craftsman-style home, and was the residence of James L. Medlin, president of the Gainesville Planing and Coffin Company. In 1983, it was converted to use as law offices.

108 SE 7ᵀᴴ STREET

Home of E.C. Pound. Aaron Keeler built this home in 1880 and four years later it was acquired by livery stable owner E.C. Pound. It started out as a single-family home, then was divided into use by two families and then to apartments occupied by the wives of officers serving at Camp Blanding during World War II. Mary Barrow converted the home to five rental spaces in 1984.

115 SE 7ᵀᴴ STREET

Home of Julian Niblack. In about 1899, this Victorian cottage was erected at 521 E. University Avenue for Atlantic Coast Line chief agent Charles H. Barnes. It later became the home of mail clerk and mercantile salesman Julian Niblack. It features ornamental brackets, a sunrise design beneath its gables and a decorated balustrade. To avoid demolition, it was moved here in 1982 and converted to two apartments by Katy Morgan.

202 SE 7ᵀᴴ STREET

Home of Thomas Shands. This Victorian-style house was built in 1903 for lumber dealer and banker Thomas W. Shands. It was acquired by psychology professor Hasse O. Enwall in 1921 and seven years later was converted to a rental apartment. The triple carriage house reached by a covered porte-cochere is not unusual for the early Gainesville homes that had automobiles.

205 SE 7ᵀᴴ STREET

Home of Thomas Swearingen. In 1903, lumber and turpentine businessman Thomas Swearingen built this Victorian-style home. He also owned the Swearingen Auto Company, one of the city's first auto dealerships. In 1957, it became the residence of ornithologist Dr. Oliver Austin Jr., who directed the Austin Ornithological Research Station on Cape Cod. In Gainesville, he served as the curator of ornithology at the Florida Museum of Natural History. Beginning in 1978, it was converted to apartments by Mark and Mary Barrow.

221 SE 7ᵀᴴ STREET

Laurel Oak Inn. This Victorian home was built in 1885 by Wilburn Lassiter and his wife, Fanny, who lived in Georgia in the summer months and wintered in Gainesville. In 1920, they sold the home to William Reuben Thomas, who converted it into two apartments on each floor and added electricity. Modifications in 1938 included a remodeling into smaller apartments, each with its own kitchen and bathroom. The house deteriorated in the 1950s and 1960s and it was condemned in 1979. Butch and Joyce Redstone acquired it in the early 1990s and began a period of renovation, completed by Monta and Peggy Burt in 1999. They opened it as the Laurel Oak Inn, a bed and breakfast, in November of 2001.

304 SE 7ᵀᴴ STREET

Home of Lewis Texada. This Frame Vernacular–style home was built in about 1880 as a farmhouse. Over the years, it has been remodeled to remove the verandas and connect the previously separate kitchen to the main house with a breezeway. During the 1940s, it took on a Colonial Revival appearance. During the 1950s, it was the home of Lewis E. Texada.

309 SE 7ᵀᴴ STREET

Home of Emmett Baird. This home was built in 1885–86 by lumberman J. Dudley Williams, who sold it to Emmett Baird by 1900. Baird operated several sawmills and the Standard Crate Company. The home has a Victorian style with an eight-foot-wide central hallway, mahogany staircase, pine floors and ten fireplaces. The tall square tower helps to make this Gainesville's only remaining French Second Empire–style home. For a time, it housed a theater group and the alternative Windsor School of Learning. Beginning in 1991, the home was restored and converted into the Magnolia Plantation, a bed and breakfast establishment.

408 SE 7ᵀᴴ STREET

Home of Lucian Gray. This house was built in 1927 adjacent to the two-car garage and office (still standing) of Lucian M. Gray, a contractor. Gray lived here and developed the Eastview subdivision during the 1920s, plus he owned a trucking business and quarry. It is a one-and-a-half-story bungalow.

SE 12ᵀᴴ STREET

1001 SE 12ᵀᴴ STREET

Abraham Lincoln Middle School. This school began as a black high school, then closed in 1969 when desegregation became the law. It later reopened as an integrated vocational school and is now a middle school.

SE 15TH Street

3400 SE 15TH Street

Boulware Springs Waterworks. Located here is the 1891 pumping station that provided all of Gainesville with water until 1913, then served a portion of the city until 1977. The facility was placed on the National Register and is now part of a public park.

SE 21ST Avenue

401 SE 21ST Avenue

Evergreen Cemetery. This cemetery is owned by the city and covers fifty acres. A four-acre portion is known as the Old Cemetery, and contains the remains of many of the early settlers and prominent citizens. At the southeast corner is a monument to members of the Gainesville Guards who succumbed to yellow fever in 1888, after being ordered to Fernandina during an epidemic. A camp to quarantine the infected was established near the intersection of the Williston Cutoff and SE 4th Street, just west of the cemetery, and the monument to the sixteen who died was originally erected on the courthouse lawn. That monument was moved here in 1922 from the northeast corner of Courthouse Square.

Archer Road

1601 SW Archer Road

Malcom Randall Department of Veterans Affairs Medical Center. A Veterans Administration hospital was approved for construction in Gainesville in October of 1945, but it was cancelled in December of the same year. It was reapproved as a 500-bed hospital on October 10, 1961. By 1962, the plans were changed to 480 beds and construction commenced on thirty-one acres in early 1964. This facility was dedicated on October 22, 1967. In 1998, it was renamed to honor its director of thirty-two years, who was known as an advocate of the establishment of outpatient clinics to reach veterans in outlying areas of the state.

Schoolhouse Road

2525 Schoolhouse Road

Lawton M. Chiles Elementary School. This school is named for the man who served as a U.S. senator from 1971 until 1989, then as Florida's governor from 1991 until 1998.

SW 1ˢᵗ AVENUE

15 SW 1ˢᵗ AVENUE

Rice Hardware Building. In addition to a grocery store, a pair of bicycle repair shops and a drugstore/doctor's office, since 1900 this single-story yellow brick building has been the home of the Seagle Furniture Store (until 1936) and then the University Furniture Store. Rice Hardware moved here in 1965 to occupy a portion of the building, and eventually filled it entirely. The original five separate shops within the building were combined to form a single large space.

SW 2ᴺᴰ AVENUE

235 SW 2ᴺᴰ AVENUE

Home of Robert Robb. This one-story Victorian-style cottage was built during 1878 on University Avenue, then twenty years later became the medical office of Dr. Robert L. Robb and his wife, Dr. Sarah Robb, who was Gainesville's first female doctor. She had been denied entrance to medical schools in the United States because she was a woman, so she attended school in Germany. In Gainesville, they practiced medicine and operated one of the nation's first boarding schools. She became a widow in 1903 and Sarah Robb continued to practice medicine from this house until 1917, concentrating on treating women and children. Later, after her death in 1937 and a period in which the house was used for businesses, the Alachua County Medical Society acquired the house and moved it here. In it was established a medical museum.

300 SW 2ᴺᴰ AVENUE

First Presbyterian Church. The first sanctuary of this congregation opened on December 1, 1859, on SE 1ˢᵗ Street. It was replaced by one dedicated in 1890 at the corner of University Avenue and NW 2ⁿᵈ Street dedicated as the Anderson Memorial, named for Pastor Dr. John G. Anderson. It was torn down in 1954 and the present church building held its first service in March of that year. Its bell is the same one that rang in 1864, alerting local residents to the approach of Union soldiers.

801 SW 2ᴺᴰ AVENUE

Alachua General Hospital. This hospital was founded in 1927, replacing many private hospitals operated in large homes or other small facilities. A portion of the land on which it is located formerly was the Tin Can Tourist Camp, a place where tourists could live in their cars or trailers while they visited the area. Alachua General merged with Shands Hospital and AvMed Santa Fe in 1996.

SW 11ᵀᴴ STREET

1080 SW 11ᵀᴴ STREET

P.K. Yonge Developmental Research School. This facility occupied Norman Hall on SW 13ᵗʰ Street on the campus of the University of Florida from its founding in 1934 until 1958. The school is affiliated with the university and develops innovative solutions to educational concerns for approximately 1,150 students from kindergarten through high school. It works closely with students and faculty of the university's College of Education. It is named for Philip Keyes Yonge, who became a member of the State Board of Control in 1905 and served on it until 1933. The school and the P.K. Yonge Library of Florida History were named to honor his commitment toward improving education.

SW 27ᵀᴴ STREET

727 SW 27ᵀᴴ STREET

The Castle. This home in the Golf View subdivision was built in 1939 with fieldstone. It features a forty-foot tower, the top of which is reached by a spiral staircase. The living room ceiling is twenty-five feet above the floor.

SW 75ᵀᴴ STREET

6221 SW 75ᵀᴴ STREET

Kanapaha Presbyterian Church. This church building was erected in 1859, making it the oldest church in the area. This congregation was the parent of First Presbyterian Church, and lost many of its members to the new one as settlers moved from the more rural area to downtown Gainesville.

UNIVERSITY OF FLORIDA CAMPUS

Listed below are several of the nearly nine hundred buildings spread across the UF campus. Most do not have traditional street numbers and may not have easily identifiable "front" doors on a single street. They are listed below with the streets they are closest to, heading westward from SW 13ᵗʰ Street or southward from University Avenue.

ARCHER ROAD

1600 ARCHER ROAD

Shands Hospital. In 1953–56, the Medical Sciences Building was erected at this site. In 1965, it was named for state senator William A. Shands, who was

largely responsible for the university obtaining the medical school. It makes up a portion of the J. Hillis Miller Health Center, named after the man who served as president of the university from 1948 until 1954.

BUCKMAN DRIVE

WEST SIDE BETWEEN UNIVERSITY AVENUE AND UNION ROAD

Fletcher Hall. This residence hall was designed by Rudolph Weaver, and was intended to be an extension of the preexisting Sledd Hall. Weaver borrowed some elements used on Sledd, including concrete European university seals and other exterior ornamentation. It opened in 1939 and has ninety-one dormitory rooms for 177 students. It is named for Duncan U. Fletcher, who served as a U.S. senator from Florida from 1908 until 1936. Fletcher Hall was added to the National Register in 1989.

Buckman Hall. This building was designed by William A. Edwards, erected in 1906–07 by the W.T. Hadlow Company of Jacksonville and was named after Henry Holland Buckman of the same city. Buckman was serving in the Florida Legislature in 1905 and, as chairman of the House Judiciary Committee, introduced the Buckman Act, which merged several small state-supported schools into a college for women in Tallahassee and a university for men in Gainesville. The combination of Thomas and Buckman Halls provided living space for 100 students, twenty-four classrooms, an assembly hall, four laboratories, a mess hall and a machinery hall. Buckman Hall was placed on the National Register in 1974. It now accommodates 124 students in its eighty-four rooms.

EAST SIDE BETWEEN UNIVERSITY AVENUE AND UNION ROAD

Leigh Hall. This 1927 Collegiate Gothic–style building was begun as the Chemistry-Pharmacy Building. Designed by Rudolph Weaver, the plans included a central open courtyard. Several times over the years, it has been enlarged. It was named for Dr. Townes R. Leigh, who served as head of the Chemistry Department.

EAST SIDE BETWEEN UNION ROAD AND STADIUM ROAD

Rolfs Hall. This was designed by Rudolph Weaver and built in 1927 as the Horticultural Science Building. During the 1950s, it was dedicated in honor of Peter Henry Rolfs, a horticulturalist and biologist for the Florida Agricultural Experiment Station in Lake City beginning in 1891, and the dean of the College of Agriculture from 1906 until 1920. It now houses the Center for Teaching Excellence. Rolfs Hall was added to the National Register in 1986.

WEST SIDE BETWEEN UNION ROAD AND STADIUM ROAD

Newell Hall. This was built in 1909–10 as the Florida Agricultural Experiment Station. It was renamed Newell Hall in 1944 and was added to the National Register in 1979. It is named for Dr. Wilmon E. Newell, who directed the Agricultural Experiment Station from 1921 until 1943.

DIAMOND ROAD

Emory Gardner Diamond Memorial Village. This complex of apartments was built to house married students and their families who were scheduled to be moved from a portion of the temporary Flavet buildings, which wound up closing in 1965. It is named for Emory Diamond, president of the student body in 1950–51 and mayor of Flavet Village II in 1949. Diamond graduated in 1950 and died in a plane crash in 1959, the year this 208-unit village opened.

FLETCHER DRIVE

WEST SIDE BETWEEN UNIVERSITY AVENUE AND UNION ROAD

Murphree Hall. This C-shaped building opened in 1939 and (with Fletcher Hall) cost $460,000. It is named after Albert A. Murphree, who served as the president of the university from 1909 until his death in 1927. It was designed by Rudolph Weaver and built by the J.M. Raymond Construction Company. Murphree Hall underwent a major renovation in 2005 and its 169 dormitory rooms accommodate 351 students.

Women's Gymnasium. This Tudor Gothic–style building was erected as a gymnasium-auditorium in 1919 after the gymnasium in Thomas Hall became outgrown. Gainesville residents helped to fund its construction to attract the 1919 New York Giants to hold their baseball spring training sessions in it. This was Florida's first indoor basketball arena and the first permanent all-purpose structure on campus. In 1947, it was designated as the gymnasium for female students, who that year were allowed to become regular students. It was added to the National Register in 1979. In 2000, the building was renamed as the Kathryn Chicone Ustler Hall, making it the first UF academic building to be named for a woman. Ustler, a 1961 graduate, and the State of Florida provided the funds for the building's $4 million renovation.

EAST SIDE BETWEEN UNIVERSITY AVENUE AND UNION ROAD

Thomas Hall. This building was designed by architect William A. Edwards and was built in 1906–07 by the W.T. Hadlow Company to be a classroom-administration building. Within a decade after its opening, it was turned into a dormitory known as Main Hall. It was renamed later as Thomas

Hall to honor Gainesville Mayor William Reuben Thomas, who had attended the East Florida Seminary and who helped attract the university to Gainesville by having the city donate 517 acres and $40,000. This was the first home of the College of Law, which opened in 1909 with two professors and thirty-one students. All that was required for admission was completion of the tenth grade, and after a two-year program that cost about $70 per year graduates were admitted into the state bar association without having to pass a bar exam. In 1914, a high school diploma was made a prerequisite, upgraded to a four-year degree in 1933. Thomas Hall also was the home of the Chemistry Department, which moved in during 1910. Thomas Hall was added to the National Register in 1974. It has 109 rooms for 170 students and is the oldest building still standing on the campus.

Sledd Hall. This residence hall designed by Rudolph Weaver opened in 1929. Its exterior features concrete designs of European university seals, plants, animals and other figures. This building is connected to Thomas Hall by a tower structure designed by university art professor W.K. Long. At its south entrance is carved the word "Mucozo," the name of the Timucuan chief who sheltered the last survivor of the sixteenth-century Panfilo de Narvaez Expedition. Sledd Hall was named after Andrew Sledd, who served as the president of the university from 1904 until 1909. Fletcher, Sledd and Thomas Halls form a giant "UF," which can be seen from aircraft flying over the university.

WEST SIDE BETWEEN UNION AND STADIUM ROADS

Infirmary. The student health center was designed by Rudolph Weaver and opened in 1930, taking over from a World War I barracks building. The site was chosen close to the athletic facilities and early dormitories. In 1947, a wing was added to the south to serve as a nursing residence. It became strictly an outpatient clinic upon the opening of Shands Hospital.

GALE LAMERAND DRIVE (PREVIOUSLY NORTH-SOUTH DRIVE)

WEST SIDE BETWEEN STADIUM ROAD AND MUSEUM ROAD

East Hall. This dormitory was opened in 1961 as part of an $8.5 million residence project including Graham, Hume, Jennings, Rawlings, Simpson and Trusler Halls. It has 105 rooms for 218 students.

Weaver Hall. Guy Fulton designed this residence hall, which opened in 1950 at a cost of $477,295. It is named for Martha Weaver, the wife of Rudolph Weaver, the first director of the School of Architectural and Allied Sciences and the first state university system architect for the Board of Control.

Graham Hall. This dormitory, with 105 rooms for 218 students, opened in 1961. It is named for Klein Harrison Graham, who served as

the university's business manager, head of the Florida Endowment Corporation and treasurer of its athletic association. When the hall was dedicated on November 3, 1962, Graham had the longest record of service with the university—forty-two years.

INNER ROAD

SOUTHWEST CORNER WITH SW 13TH STREET

Mallory Hall. This dormitory opened in 1950 to accommodate female students. Beginning in 1924, women were allowed to attend classes that were offered at the University of Florida but not at the Florida State College for Women (now Florida State University). In 1947, 500 women were admitted as the first regular University of Florida female students. This and nearby halls were constructed on a former cattle pasture to provide affordable housing and replaced off-campus facilities that had been leased by the university. Mallory Hall is named for Angela Mallory, the wife of Stephen R. Mallory, who served as a U.S. senator and the secretary of the navy of the Confederacy. It became coed (by floor) in 2004 and has ninety-one rooms for 175 students.

SOUTH SIDE BETWEEN SW 13TH AND NEWELL DRIVE

Reid Hall. This dormitory opened in 1950 at a cost of $514,760.88. It was the home for female students who had previously been required to utilize overcrowded off-campus facilities. It is named after Mary Martha Reid, the wife of Robert Raymond Reid, the territorial governor of Florida from 1839 to 1841. During the Civil War Mary Reid established a hospital in Richmond, Virginia, to care for sick and wounded soldiers from Florida. Reid Hall has eighty-seven rooms for 168 students.

Yulee Hall. This dormitory opened in 1950 for female students. In the 1970s, 1980s and 1990s, its residents were limited to sophomores and above who maintained a grade point average of 3.0 or above, but in 2001 that requirement was removed. It is named after Nancy Wickliff Yulee, the wife of Florida's first U.S. senator, David Levy Yulee, and the daughter of the governor of Kentucky. Her daughter, Florida Yulee Neff, donated generously to the university. Yulee Hall accommodates 177 students in its ninety-four rooms.

Broward Hall. This $1.66 million dormitory opened in 1954 and was designed by Guy Fulton. It initially was a women's residence hall and in 1972 became a coed dorm. It is named for Annie Douglass Broward, the wife of Governor Napoleon B. Broward. She helped organize the Florida Parent-Teachers Association, supported educational, charitable and public welfare programs and campaigned for child welfare laws and women's equal rights. Its 325 rooms accommodate 690 residents.

MURPHREE WAY

EAST SIDE BETWEEN UNIVERSITY AVENUE AND UNION ROAD

Smathers Library. The University Library began in Thomas Hall and moved to Peabody Hall in 1912. This facility was built as Library East to house a rapidly expanding collection. It was designed by architect William A. Edwards in 1923 and opened in 1925. In 1931, a wing designed by Rudolph Weaver was added. The building helps define the limit of the Plaza of the Americas along with Peabody Hall, Anderson Hall, Floyd Hall, Flint Hall and the University Auditorium. Library East was remodeled and expanded in 1949 and added to the National Register in 1979. It was renamed in 1991 as the Smathers Library to honor U.S. Senator George Smathers.

MUSEUM ROAD

SOUTHWEST CORNER WITH SW 13ᵀᴴ STREET

Beaty Towers. This pair of high-rise dormitories is named for Robert Calder Beaty, who came to the university to work with the on-campus YMCA program. He also taught sociology and served as the assistant dean and dean of students. The towers were designed by Forrest Kelly and were built by the Edward M. Fleming Construction Company for a total cost of $3.25 million. They opened in 1967 and were dedicated on June 12, 1971. They have two hundred rooms for 787 students, plus a convenience store, a commons building for group activities and a telephone service office.

SOUTH SIDE BETWEEN SW 13ᵀᴴ STREET AND NEWELL DRIVE

Jennings Hall. This dormitory opened in 1961 and was dedicated on November 3, 1962, as part of an $8.5 million project with four other residence halls. It was initially a women's dorm and is named after May Austin Mann Jennings, the wife of William Sherman Jennings, Florida's governor from 1901 until 1919. She was active in the establishment of the Everglades National Park and served as the vice-president of the National Federation of Women's Clubs. Jennings Hall has 248 rooms for 520 residents.

NORTH SIDE BETWEEN NEWELL DRIVE AND GALE LAMERAND DRIVE

J. Wayne Reitz Union. This facility, named after university president J. Wayne Reitz, was completed in 1967 and replaced the student union located in what is now the Arts and Sciences Building (Dauer Hall). Included is the Constans Theatre, named after Professor Philip Constans, chairman of the Speech Department and director of the Constans Players.

Southeast corner with Newell Drive

WRUF-UFPD Building. Unusual for the campus, this building has a Tudor Revival style with half-timbering. When built in the 1920s, it served as the original home of the campus radio station. WRUF, which began broadcasting in October of 1928, moved to another location in 1957, and the building became the headquarters of the campus police.

Southwest corner with Newell Drive

Joshua C. Dickinson Jr. Hall. This unusual building, partly underground with a portion of its roof covered with grass, houses the Education and Exhibition Center of the Florida Museum of Natural History. It was completed in 1971 and one of its most popular exhibits is a walk-through replica of a north Florida cave. The building was dedicated to honor the director of the museum from 1959 until 1979. It was designed by William Morgan to resemble a Native American temple mound. Additional exhibit space is found in Powell Hall on Hull Road.

South side between Newell Drive and Center Drive

Rogers Hall. This building was completed in 1955 and was named for Frazier Rogers, chair of the Department of Mechanical Engineering. It is now the home of the Department of Agricultural and Biological Engineering.

Bartram Hall. Formally known as the William Bartram Biological Sciences Building for the naturalist who traveled throughout the Southeast during the 1770s, this building was completed in the 1970s and houses many activities related to biology.

Carr Hall. This brick building was dedicated in 1967 to Archie L. Carr Jr., one of the university's first graduate research professors. It houses the Carr Center for Sea Turtle Research.

South side between Gale Lamerand Drive and Woodlawn Drive

Simpson Hall. This residence hall opened in 1961 and has 109 rooms for 225 students. It is named for Thomas Marshall Simpson, who served as a professor of mathematics and as dean of the Graduate School.

Trusler Hall. This dormitory designed by Guy Fulton opened in 1961 and has 104 rooms for 208 residents. It is named for Harry Raymond Trusler, an original member of the faculty of the College of Law and a dean of that college.

2300 Newberry Road

**University Women's Club.* An organization of faculty wives known as the University of Florida Dames began on March 6, 1922. They originally met

in the home of the Twentieth Century Club, later called the Gainesville Woman's Club. Later, the Dames were renamed the University Women's Club and met in the former Perry house, which the university had received as a gift. Today the organization includes the wives of male faculty and staff, plus female members of the faculty and staff. A major project of the club is the awarding of scholarships named for the wives of former University of Florida presidents. For many years, its clubhouse was located at this site, now part of the tennis center.

NEWELL DRIVE

WEST SIDE BETWEEN UNIVERSITY AVENUE AND UNION ROAD

Flint Hall. This building was constructed in 1910 as the home of the Science Department and was named Science Hall. Its cost, when combined with that of the Agricultural Experiment Station, was $68,950. Limited funds resulted in few exterior ornamental details. During the late 1950s, its name was changed to honor Dr. Edward Rawson Flint, who had served as a member of the faculty of the Florida Agricultural College, was the university's resident physician and established the university infirmary. Flint was awarded an honorary degree from the university in 1919. Flint Hall deteriorated greatly, classes were moved out of it and for years it was used for the storage of records and books. Further deterioration led to its being padlocked and empty for many years. A former dean and other historic preservationists raised $3 million to restore it and Anderson Hall, making both usable once again. It was placed on the National Register in 1979.

WEST SIDE BETWEEN INNER ROAD AND MUSEUM ROAD

Dairy Science Building. This building was designed by Rudolph Weaver and opened in 1937 with classrooms, offices, laboratories and cold storage rooms.

McCarty Hall. This is the central administrative office of the Institute of Food and Agricultural Sciences (IFAS), a portion of the university that is funded by state, federal and local governments. Its mission is to sustain and enhance the quality of life through knowledge of human and natural resources, agriculture and the life sciences. IFAS has centers located on campus and in every Florida county. The four connected buildings, completed during the 1950s, are collectively named for Daniel T. McCarty, a UF alumnus and former governor of Florida.

EAST SIDE BETWEEN INNER ROAD AND MUSEUM ROAD

Rawlings Hall. In 1958, this dormitory was built for women at a cost of $1.15 million. It was designed by Guy Fulton and its 176 rooms accommodate 364 students. It is named after Marjorie Kinnan Rawlings, the Pulitzer

Prize–winning author of *The Yearling* and other books. Rawlings moved to nearby Cross Creek in 1928 and became involved with the university. She willed it her library, manuscripts and estate.

STADIUM ROAD

SOUTHWEST CORNER WITH SW 13ᵀᴴ STREET

Architecture–Fine Arts Complex. The School of Architecture was established in 1925 with director Rudolph Weaver and a program administered by the College of Engineering. This complex took nearly twenty years to complete, with the first of its six buildings opening in 1965 at a cost of $1.5 million.

SOUTH SIDE BETWEEN SW 13ᵀᴴ STREET AND NEWELL DRIVE

Little Hall. This building is named for Winston W. Little, who in 1937 became the second dean of the University College. Little Hall was completed in 1965 for the University College and provided classrooms, teaching auditoriums and faculty offices.

NORTH SIDE BETWEEN SW 13ᵀᴴ STREET AND NEWELL DRIVE

Carlton Auditorium. Designed by Guy Fulton, this one-story teaching auditorium opened in 1954. The 680-seat hall is named for "Wild Bill" Carlton, a popular social sciences and history professor from 1926 to 1962.

NORTHEAST CORNER WITH NEWELL DRIVE

Century Tower. Construction of this tower began in 1953, when the university was one hundred years old, and was completed in 1955. Originally, the interior was to be a museum and art gallery, but plans were changed. It housed the Milton and Ethel Davis Carillonic Bells, which were donated by A.D. and J.E. Davis in honor of their parents. On May 14, 1979, the bells were replaced with the forty-nine-bell Century Tower Carillon, the largest bell of which weighs about seven thousand pounds.

SOUTHWEST CORNER WITH NEWELL DRIVE

Marston Science Library. In 1987, this facility opened as the home of the university's collections of materials in the fields of science, engineering, mathematics and agriculture. Other research materials include maps and aerial and satellite photographs. The building is named for the university's seventh president, Robert Q. Marston.

NORTH SIDE BETWEEN BUCKMAN DRIVE AND FLETCHER DRIVE
Bryant Space Sciences Building. In 1967, this was built as the Space Center Research Building. It is now named for Thomas Bryant, a member of the Board of Control.

SOUTH SIDE BETWEEN BUCKMAN DRIVE AND FLETCHER DRIVE
The Hub. In 1950, this building was erected with Art Deco elements, exhibiting a break from the previous Collegiate Gothic style. In its early years, it had a movie theater and soda fountain, then became the campus bookstore. After 2000, it was remodeled as a food court and the bookstore was moved to a larger new building adjacent to the student union.

SOUTH SIDE BETWEEN FLETCHER DRIVE AND
GALE LAMERAND DRIVE
Williamson Hall. Built in the early 1960s, this is the physics building, including the Bless Auditorium named for Arthur A. Bless in 1967. The building is named for Robert C. Williamson, who chaired the Physics Department from 1930 until 1958.
Weimer Hall. This building was dedicated in 1980 and the following year was named after Dr. Rae O. Weimer, the former dean of the College of Journalism and Communications. That college's offices were previously located beneath the seats of the stadium.
Weil Hall. During the late 1940s, this opened as the Engineering Industries Building. It was designed by Guy Fulton and was named for Dean Joseph Weil, who headed the college from 1937 until 1963. It now houses the College of Engineering.
Nuclear Sciences Building. Connected to Weil Hall, this facility was completed in the mid-1960s and contains a four-million-volt Van de Graaff accelerator.

NORTH SIDE BETWEEN FLETCHER DRIVE AND
GALE LAMERAND DRIVE
Florida Gymnasium. This gymnasium was dedicated in 1949 and was the home of the basketball teams until the O'Connell Center opened in late 1980. It was nicknamed Alligator Alley and in addition to basketball hosted political speeches, concerts and other entertainment.

NORTHWEST CORNER OF STADIUM ROAD AND
GALE LAMERAND DRIVE
O'Connell Student Activity Center. This facility opened in December of 1980. It includes a twelve-thousand-seat main arena, dance studio, weight and exercise rooms and an Olympic-sized swimming pool. The building covers 3.6 acres and can accommodate about one thousand people

simultaneously involved in instruction and recreation in at least nine different activities.

Van Fleet Hall. In 1952, this three-story brick building was constructed for the ROTC. It is named after the commandant of the army ROTC and a professor of military science and tactics during the 1920s, Major James A. Van Fleet. He also coached the football team in 1923 and 1924.

NORTH SIDE BETWEEN GALE LAMERAND DRIVE AND VILLAGE DRIVE

Carl Perry Baseball Diamond and McKethan Stadium. This baseball field is named after Carl "Tootie" Perry, who served as the captain of the 1921 football team and for years was known as the "All-American Water Boy." The 4,500-seat stadium is dedicated in honor of banker Alfred A. McKethan.

Percy Beard Track and Field Complex. This athletic complex bears the name of Percy Beard, the coach of the university's track and field teams from 1937 until 1963.

SOUTH SIDE BETWEEN GALE LAMERAND DRIVE AND WOODLAWN DRIVE

North Hall. Guy Fulton designed this residence hall, which opened in 1950 at a cost of $392,995. It has eighty-five rooms for 158 students. It will likely be dedicated some day with the name of a member of the university's faculty or staff, or some other prominent individual.

Riker Hall. This dormitory opened as South Hall in 1950 and has 105 rooms for 196 students. In 2000, it was dedicated to honor Dr. Harold C. Riker, who served for twenty-nine years as the university's director of housing.

Tolbert Hall. This dormitory was designed by Guy Fulton, and it opened in 1950 at a cost of $562,295. It is named for Benjamin A. Tolbert, professor of education and dean of freshmen (then dean of students). He supported a program of loans to allow students to attend school during the Great Depression.

UNION ROAD

NORTH SIDE BETWEEN SW 13TH STREET AND NEWELL DRIVE

Marshall M. Criser Student Services Center. Included in this building are the offices of the university registrar, admissions and student financial affairs. It is named for the eighth president of the university and was dedicated in 1991. It is linked to Peabody Hall, which has a similar architectural style.

Peabody Hall. This was designed by William A. Edwards and built in 1913 with a George Peabody Foundation grant of $40,000 to house the Teacher's College. From 1912 to 1925 it also served as the university library and was

one of the four original buildings defining the Quadrangle. It was added to the National Register in 1979.

SOUTH SIDE BETWEEN SW 13ᵀᴴ STREET AND NEWELL DRIVE

Walker Hall. Rudolph Weaver designed this building, which was completed in 1927 as the Mechanical Engineering Building. It was renamed after Major Edgar S. Walker, who taught military science and tactics and civil engineering. During the 1970s, it was renovated for the Department of Mathematics.

Grinter Hall. The present building is named for Linton E. Grinter, dean of the Graduate School from 1952 until 1969. It replaced Benton Hall, built in 1911 for the College of Engineering and torn down in 1969. Grinter Hall was completed in 1971 and houses the Office of Research, Technology and Graduate Education, and the Center for African and Latin American Studies.

University Auditorium. This magnificent Collegiate Gothic structure was designed by William A. Edwards and partially built in 1922–25. It served the university for all assemblies, including chapel. It was finally completed by the addition of the north façade in 1977. The university had a $100,000 appropriation for the building, but total costs over the fifty-five years amounted to about $6 million. It seats 867 and is used for concerts and special lectures. It featured the Anderson Memorial Organ, later replaced by the 5,408-pipe Aeolian Skinner Organ.

SOUTHWEST CORNER WITH NEWELL DRIVE

Turlington Hall. When completed in 1978 for $5.7 million, it was the largest classroom building on campus. Initially known as General Purpose Building A, it was renamed to honor Ralph Turlington, Florida's commissioner of education from 1974 until 1987. It sits on the former site of the first building erected on the campus, a small wooden machinery structure. Called Machinery Hall, it served as a storage facility, a chemistry laboratory and, starting in 1928, the university post office. Later it was the home of the Alumni Association and the University News Bureau.

NORTHWEST CORNER WITH NEWELL DRIVE

Griffin-Floyd Hall. This building was erected in 1912 to house the Agriculture College. Until 1918, in it was located an assembly room and chapel. Floyd Hall was named for Major Wilbur L. Floyd, who taught biology, physics and horticulture and served as the assistant dean of the College of Agriculture from 1915 until 1938. It was added to the National Register in 1979, but sat unused for a long time and was scheduled to be torn down. A gift of $2 million from alumnus Ben Hill Griffin Jr. allowed the university to renovate and restore the building, which reopened in 1992.

NORTHWEST CORNER WITH BUCKMAN DRIVE

Dauer Hall. This building was completed here in 1936 as the student union, including hotel rooms for visitors, a small library, chapel, game room, banquet hall, sundry shop, soda fountain, bookstore and an office for student organizations. One of the fundraisers for the construction of the building was William Jennings Bryan. Later, portions of the second floor were assigned to the Religion Department and the YMCA. It was dedicated in honor of Department of Political Science chair Manning Dauer. When the Reitz Union was completed in 1967, this building was converted to the Arts and Sciences Building.

W. UNIVERSITY AVENUE

BETWEEN SW 13TH STREET AND NEWELL DRIVE

Matherly Hall. Guy Fulton designed Matherly Hall for use as a classroom building. This Collegiate Gothic–style building erected in the 1950s faces the Emerson Courtyard, an open air forum and gathering place for the Warrington College of Business Administration. Matherly Hall is named for Walter Jeffries Matherly, College of Business Administration dean from 1926 until 1954.

Anderson Hall. This building was erected in 1913 as a general purpose building and was originally called Language Hall. It was designed by William A. Edwards, the official architect of the Board of Control. The building was renamed Anderson Hall to honor Latin and Greek professor Dr. James Nesbitt Anderson, who served as the first dean of the Graduate School. This was placed on the National Register in 1979.

SOUTHEAST CORNER WITH NEWELL DRIVE

Library West. This facility opened in 1967 as a graduate research library. It was renovated in the early 1990s and now houses the humanities collection and other materials. It links to the Smathers Library via a covered walkway.

SOUTHEAST CORNER WITH GALE LAMERAND DRIVE

Ben Hill Griffin Stadium at Florida Field. In the fall of 1930, this football stadium was built in a pasture behind the gymnasium. It then had 21,769 seats and was dedicated to the memory of the Florida men who died in World War I. Lights were purchased with money donated by Georgia Seagle, who also donated funds for the construction of Georgia Seagle Hall to house university athletes off campus. In the halls beneath the stadium's seats have been many university facilities, including an athletic dormitory named Yon Hall, the College of Journalism offices and radio station WRUF. The south end zone project of 1982 increased the seating capacity to more than 72,000, and nine years later the addition of the north end zone seats

brought the number to more than 84,000. Another renovation in 2003 increased the capacity to 88,548, making it the largest stadium in the state. It was dedicated in 1989 to honor Ben Hill Griffin Jr., a university supporter and generous benefactor.

SOUTHWEST CORNER WITH SW 2ND AVENUE

President's House. President and Mrs. John Tigert used their house at 224 NE 10th Avenue for university functions, but it was too small to receive all of the faculty and their wives at one time. The university then built a new home for its president on this triangular five-acre tract, costing $125,000. It has a Neoclassical style and was designed by Jefferson Hamilton. It was occupied by several student organizations until the next president, J. Wayne Reitz, moved in.

VILLAGE DRIVE

William W. Corry Memorial Village. This on-campus cluster of 216 apartments opened in 1959 for married students returning to school after military service. The village is named for William Walden Corry, president of the student body in 1942–43. After graduation with honors, Corry volunteered for military service and was killed in action in France in February of 1945.

SW 2ND AVENUE

SOUTH SIDE BETWEEN UNIVERSITY AVENUE AND VILLAGE DRIVE

Scott Linder Tennis Stadium and Ring Tennis Pavilion. This facility is named for university alumnus and contributor R. Scott Linder and philanthropist Alfred A. Ring. The stadium and pavilion opened in 1987 and 1996, respectively.

SOUTHEAST CORNER WITH VILLAGE DRIVE

Holland Hall. The first portion of this complex built for the College of Law opened as the Spessard L. Holland Law Center (named for a U.S. senator) in 1969, and was expanded by the addition of Bruton-Geer Hall in 1984. It was initially named after the parents of Judge James Bruton and Quintilla Geer Bruton, and in 1998 the name of attorney Fredric Levin was added. Near the law school is a burial mound dating to about AD 1000 by ancestors of the Potano natives, probably residents of the land around nearby Lake Alice. The mound was first dug in 1881 and was excavated on behalf of the Florida State Museum in 1976.

SOUTHEAST CORNER WITH SW 34TH STREET

University Golf Course and Bostick Club House. In 1962, the university acquired
the Gainesville Golf and Country Club, which had opened in 1924, and
the university now hosts intercollegiate tournaments there. In 1988, the
Guy Bostick Club House was built and dedicated to honor a university
alumnus and booster of the golf program.

SW 13TH STREET

WEST SIDE BETWEEN UNIVERSITY AVENUE AND UNION ROAD

Bryan Hall. The College of Law was established on September 29, 1909,
and was housed in a single room. In 1910, it expanded to three rooms
on the third floor of Thomas Hall. Bryan Hall was dedicated as its new
home on November 20, 1914, and was expanded with the addition of a
library wing in 1941 and a court/auditorium in 1950. It is named after
Nathan Philemon Bryan, the first chairman of the Board of Control,
which was responsible for determining what buildings would be erected
and where. Bryan was born in 1872, served as a United States senator
and is largely responsible for the establishment of the College of Law at
this university. This building was added to the National Register in 1979
and became a part of the College of Business Administration.

SOUTHWEST CORNER WITH UNION ROAD

Tigert Hall. This building was erected in 1950 and was dedicated on October
15, 1960, as Tigert Hall. It is named for Dr. John J. Tigert, who was the
university president from 1928 until 1947. It serves as the university's
main administration building and houses the offices of the president and
other officers.

SOUTHEAST CORNER WITH SW 5TH STREET

Norman Hall. When this was built in the 1930s, it was the P.K. Yonge Laboratory
School. That school moved out in 1958 and the building was dedicated to
honor Dean James W. Norman, who headed the College of Education from
1920 to 1955. It is now the home of that college.

2901 SW 13TH STREET

Tanglewood Apartments. This 208-unit apartment complex was built in 1968–72
and was acquired by the university for $2.6 million in 1973. Its acquisition
eliminated the need for construction of another on-campus married housing
village, and allowed Flavet Village III to close on June 30, 1974.

SW 34TH STREET

Raymer Francis Maguire Memorial Village. This complex of 220 apartments for married students opened in 1971–72. It is named for the man who served as president of the student body in 1914–15, received the President's Medal for service to the university in 1935 and was named the university's Outstanding Alumnus in 1953.

University Village South. This is a complex of 128 apartments for married students and their families, which opened in 1973.

Appendix:

NAME CHANGES
TO GAINESVILLE'S
STREETS AS OF
JULY 1, 1950

NORTHEAST QUADRANT

New Name	Old Name(s)
Boulevard	Boulevard
Main Street	W. Main Street
University Avenue	University Avenue (until about 1905, Liberty Street east of Sweetwater Branch and Alachua Avenue to the west)
Waldo Road	Waldo Road
1st Avenue	1st Avenue, Mechanic Street
1st Street	E. Main Street
2nd Avenue	Florida Court, Orange Street

New Name	Old Name(s)
2nd Street	Virginia Avenue, Virginia Street
3rd Avenue	Court Street
3rd Street	Florida Avenue, Oak Street, Factory Street
4th Avenue	Church Street
4th Street	Bay Street, Cherokee Street
5th Avenue	Seminary Street
5th Street	Kentucky Avenue, Myrtle Street, Palm Avenue
5th Terrace	Holly Street, Seminole Avenue
6th Avenue	Lassiter Street
6th Street	Franklin Street
7th Avenue	Columbia Street, Forest Avenue, Leigh Terrace
7th Street	Roper Street
7th Terrace	Florida Court, Pine Terrace
8th Avenue	Boundary Street
8th Street	Palmetto Street
9th Avenue	2nd Avenue, Florida Terrace
9th Street	Evans Street
10th Avenue	Boulevard, Tuscawilla Avenue
10th Place	4th Avenue
10th Street	Government Street

New Name	Old Name(s)
11th Avenue	Maryland Avenue
11th Street	16th Street, Yulee Street
12th Avenue	6th Avenue
12th Street	Viola Street
12th Terrace	8th Street
13th Place	13th Place
13th Street	E Street
14th Avenue	Olive Street
14th Street	F Street
15th Place	15th Place
15th Street	Denver Street, G Street
16th Avenue	Michigan Street

NORTHWEST QUADRANT

New Name	Old Name(s)
Main Street	W. Main Street
University Avenue	University Avenue
1st Avenue	Mechanic Street, Nelson Avenue
1st Place	Hernando Street, Mechanic Street
1st Street	Garden Street
2nd Avenue	Leon Street, Orange Street, Pearson Street

New Name	Old Name(s)
2nd Street	Pleasant Street
3rd Place	Fletcher Terrace, Onondaga Place
3rd Street	Arredonda Street
4th Avenue	Church Lane, Church Street, Tressalia Street
4th Place	Duke's Court, Seminary Lane
4th Street	Grove Street
5th Avenue	Seminary Lane, Seminary Street
5th Place	Dickinson Lane, Dickinson Place
5th Street	Meador Street
6th Avenue	6th Street, Brown Lane, Brown Street, Grove Lane, Lassiter Street, Thomas Street
6th Place	Nassau Street
6th Street	5th Street, Alabama Street, Albany Place
6th Terrace	Columbia Lane
7th Avenue	Columbia Street
7th Lane	Broome Street, Perkins Lane
7th Place	7th Court, Arredonda Court, Stewart's Lane, Tison Street, Woodlawn Avenue
7th Street	Shipps Lane, Wilson Street

New Name	Old Name(s)
7th Terrace	7th Terrace, Benson Street, Thomas Lane
8th Avenue	Boundary Street
8th Place	Garden Street
8th Street	6th Street, Palmetto Street, Sycamore Street
9th Avenue	2nd Avenue, 9th Terrace, Gordon Street, Pistol Alley
9th Street	Clarks Lane
9th Terrace	Smith Street
10th Avenue	Cypress Street
10th Street	7th Street
11th Avenue	Penn Avenue
11th Street	Cedar Street
12th Avenue	Hampton Street
12th Drive	Bellah Street, Dakin Court, Sanchez Lane
12th Street	8th Street
12th Terrace	8th Terrace, Elm Street, Ilex Drive, University Terrace
13th Avenue	13th Avenue, Newport Street, Wilma Street
13th Street	9th Street
13th Terrace	F Street, Hampton Street
14th Avenue	Olive Street

New Name	Old Name(s)
14th Street	Roux Street
15th Avenue	Gerard Street
15th Street	Washington Street
15th Terrace	Colson Street
16th Avenue	Michigan Street
16th Street	Lafayette Street
17th Avenue	Benton Court
17th Street	DeSoto Street
18th Avenue	Lake Avenue
18th Street	College Park Avenue
19th Avenue	Sheldon Avenue
19th Street	Waukulla Street
20th Drive	Ray Street
20th Street	Osceola Street
20th Terrace	College Court
21st Street	Ferndale Street
21st Terrace	Chesnut Court
22nd Drive	Ellsworth Street
22nd Street	Hilldale Street

SOUTHEAST QUADRANT

New Name	Old Name(s)
Depot Street	Depot Street
Main Street	W. Main Street
University Avenue	University Avenue
1st Avenue	King Street, Plant Street, Union Street
1st Street	Gas Street, E. Main Street, Veach Street
2nd Avenue	Masonic Street, Oddfellow Street, Williams Street
2nd Place	Magnolia Street
2nd Street	Virginia Street
3rd Avenue	4th Avenue, McCormick Street
3rd Street	Oak Street, State Street
4th Avenue	Arlington Place, Arlington Street
4th Place	Lemon Street, Orleans Street
4th Street	Bay Street, Pearl Street
5th Avenue	Market Street, Middle Street
5th Street	Cleveland Street, Myrtle Street
5th Terrace	Bird Street
6th Avenue	Cecil Drive, Julia Street, Pine Street
6th Street	Dell Street

New Name	Old Name(s)
6th Terrace	6th Terrace
7th Avenue	Depot Street
7th Place	Bristow Street
7th Street	Roper Street
8th Avenue	10th Avenue
9th Place	Gregory Street
9th Street	9th Street, Evans Street
10th Avenue	12th Road, Miller Street
10th Place	13th Avenue
10th Street	Government Street, South Lane, Spring Hill Street
11th Avenue	14th Avenue
11th Street	Cecil Drive, Spring Hill Street, Yulee Street
12th Street	D Street, Foraker Avenue, Viola Street
12th Terrace	Lincoln Avenue
13th Road	Dump Road
13th Street	E Street
13th Terrace	E Street
14th Street	F Street

SOUTHWEST QUADRANT

New Name	Old Name(s)
Main Street	W. Main Street
University Avenue	University Avenue
1^{st} Avenue	Union Street
1^{st} Street	Garden Street
2^{nd} Avenue	Masonic Street
2^{nd} Lane	Dell Lane
2^{nd} Place	Magnolia Street
2^{nd} Street	Pleasant Street
2^{nd} Terrace	Delaware Street
3^{rd} Avenue	McCormick Street
3^{rd} Street	Arredonda Street
4^{th} Avenue	Arlington Street
5^{th} Avenue	Margaret Street, Market Street
5^{th} Street	Porter Street
5^{th} Terrace	Moss Street
6^{th} Avenue	8^{th} Avenue, Pine Street, West Street
6^{th} Place	Black Street
6^{th} Street	5^{th} Street, Commerce Street
6^{th} Terrace	6^{th} Terrace
7^{th} Avenue	New Gainesville Street

New Name	Old Name(s)
7th Place	9th Place, May Street
7th Street	Wilson Street
7th Terrace	6th Street
8th Avenue	Georgia Avenue, Mill Street
8th Place	6th Street, Green Street
8th Street	6th Street, Benson Street, Davis Lane
9th Avenue	Yonge Court
9th Road	13th Street
9th Street	Taylor Street
10th Street	7th Street
11th Avenue	Edwards Street
12th Street	New Gainesville Street
12th Terrace	New Gainesville Street
13th Street	9th Street, Livingston Avenue
13th Terrace	New Gainesville Street

BIBLIOGRAPHY

Andersen, Lars. *Paynes Prairie: The Great Savanna: A History and Guide*. Sarasota, FL: Pineapple Press, Inc., 2004.

Barr, Melanie. *History of Baird Hardware Company, Gainesville, Florida*. Gainesville: Hoch Shitama, Akira and Associates, Ltd., 1984.

Beckmann, Chris. *A History of Gainesville and Its People*. Gainesville: Oak Hall School, 1994.

Bondy, Valerie C. *Florida Bed & Breakfast Guide*. Melbourne, FL: Queen of Hearts Publications, 1995.

Boone, Floyd E. *Boone's Florida Historical Markers & Sites*. Moore Haven, FL: Rainbow Books, 1988.

Broward, Robert C. *The Architecture of Henry John Klutho*. Jacksonville, FL: University of North Florida Press, 1983.

Buchholz, F.W. *History of Alachua County, Florida, Narrative and Biographical*. St. Augustine, FL: The Record Company, 1929.

Burton, Rie, and Sam Gowan. *The Thomas Center: An Illustrated History & Guide*. Gainesville: The Alachua Press, Inc., 2001.

Burtz, Jesse E. *Burtz' Gainesville Directory for 1905–1906*. Gainesville: J.E. Burtz, 1906.

Cobb, Arthur. *Go Gators! Official History, University of Florida Football: 1889–1967*. Pensacola, FL: Sunshine Publishing Company, 1967.

Davis, Jess G. *History of Alachua County, 1824–1969*. Gainesville: Alachua County Historical Commission, 1969.

———. *History of Gainesville, Florida With Biographical Sketches of Families*. Gainesville: Jess G. Davis, 1966.

Dunn, Hampton. *Wish You Were Here: A Grand Tour of Early Florida Via Old Post Cards*. St. Petersburg, FL: Byron Kennedy and Company, 1981.

Ellerbe, Helen Cubberly. *History Walk Around Downtown Gainesville*. Gainesville: Helen Cubberly Ellerbe, 1969.

First Presbyterian Church. *First Presbyterian Church, Gainesville, Florida, 1867–1980*. Gainesville: First Presbyterian Church, 1980.

Florida Association of the American Institute of Architects. *Guide to Florida's Historic Architecture*. Gainesville: University Press of Florida, 1989.

Gainesville Letter Shop. *City Directory of Streets and Numbers*. Gainesville: Gainesville Letter Shop, 1950.

Gainesville Lodge. *The First Century of Gainesville Lodge No. 41, F.&A.M., Gainesville, Florida, 1857–1957*. Gainesville: Wayside Press, 1957.

Hildreth, Charles Haisley. *A History of Gainesville, Florida*. Gainesville: University of Florida, 1954.

Hildreth, Charles H., and Merlin G. Cox. *History of Gainesville, Florida*. Gainesville: Alachua County Historical Society, 1981.

Historic Gainesville, Inc. *Historic Gainesville...A Walking and Windshield Tour*. Gainesville: Historic Gainesville, Inc., 1983.

Holy Trinity Episcopal Church. *Church of the Holy Trinity: A Panorama of Our Parish*. Gainesville: Holy Trinity Episcopal Church, 1991.

Johnson, Margaret K. *Sentimental Journey: A Look Back at Gainesville and Alachua County in the 1940s*. Gainesville: The Alachua County Historic Trust, 2006.

Jones, Maxine D., and Kevin M. McCarthy. *African Americans in Florida*. Sarasota, FL: Pineapple Press, Inc., 1993.

Klingman, Peter D. *Josiah Walls, Florida's Black Congressman of Reconstruction*. Gainesville: The University Presses of Florida, 1976.

Laurie, Murray D. *The Matheson House of Gainesville, Florida: Sheltering the Past.* Gainesville: The Alachua Press, Inc., 2000.

Limper, Henry W. *A Century of Methodism in Gainesville.* Gainesville: First Methodist Church, 1957.

McCarthy, Kevin. *Black Florida.* New York: Hippocrene Books, 1995.

McCarthy, Kevin, and Murray D. Laurie. *Guide to the University of Florida and Gainesville.* Sarasota, FL: Pineapple Press, Inc., 1997.

McCormick, Fenwick Donald. *Planters, Plantations & Presbyterians: Kanapaha & Reverend W.J. McCormick.* Gainesville: Fenwick Enterprises, 2001.

Nulty, William H. *Confederate Florida: The Road to Olustee.* Tuscaloosa: University of Alabama Press, 1990.

Opdyke, John B., ed. *Alachua County: A Sesquicentennial Tribute.* Gainesville: The Alachua County Historical Commission, 1974.

Osborn, George C. *The First Baptist Church, Gainesville, Florida, 1870–1970.* Gainesville: Storter Printing Co., Inc., 1970.

———. *John James Tigert: American Educator.* Gainesville: The University Presses of Florida, 1974.

Owen, Lorrie K., ed. *Dictionary of Florida Historic Places, Volume One.* St. Clair Shores, MI: Somerset Publishers, Inc., 1999.

Pickard, John B. *Florida's Eden: The Illustrated History of Alachua County.* Gainesville: Maupin House, 1994.

———. *Historic Gainesville: A Tour Guide to the Past.* Gainesville: The Alachua Press, Inc., 2001.

Proctor, Samuel, and Wright Langley. *Gator History: A Pictorial History of the University of Florida.* Gainesville: South Star Publishing Company, 1986.

Rudderman, Gussie. *Gainesville Women of Vision.* Gainesville: Coronado Publishers, 1980.

Sandler, Roberta. *Guide to Florida Historical Walking Tours.* Sarasota, FL: Pineapple Press, Inc., 1996.

Spencer, Donald D. *Florida's Historic Forts, Camps and Battlefields: A Pictorial Encyclopedia.* Ormond Beach, FL: Camelot Publishing, 2006.

Tassinari, Anita Mitchell. *A Wider Vision: A History of the Gainesville Woman's Club, 1903–1995.* Gainesville: Gainesville Woman's Club, 1995.

Van Ness, Carl. *Honoring the Past, Shaping the Future: The University of Florida, 1853–2003.* Gainesville: University of Florida's 150th Anniversary Committee, 2003.

Weaver, C. Douglas. *Every Town Needs a Downtown Church: A History of First Baptist Church, Gainesville, Florida.* Brentwood, TN: Southern Baptist Historical Society, 2000.

Webber, Carl. *The Eden of the South.* Micanopy, FL: Micanopy Publishing Co., 1995 reprint of 1883 material.

Winsberg, Morton D. *Florida's History Through Its Places: Properties in the National Register of Historic Places.* Tallahassee: Florida State University, 1988.

INDEX

ABOUT THE AUTHOR

S teve Rajtar grew up near Cleveland, Ohio, came to Florida to go to college, earned degrees in mathematics, anthropology, law and taxation (the last two at the University of Florida) and decided to stay. He's been involved with the Boy Scouts for over twenty-five years and is an activity leader with the Florida Trail Association. The combination of a love of the outdoors and local history has resulted in his establishment of over 150 historical tour routes through the communities of central Florida, which can be used by anyone to get up close and personal with the region's historic sites. He has written several books on various aspects of hiking and history and loves to guide tours by foot, bicycle and kayak.

Please visit us at
www.historypress.net

CPSIA information can be obtained
at www.ICGtesting.com
Printed in the USA
LVHW071520231221
707051LV00027B/378